沖縄の デザイン マンホール 図鑑

A Picture Book of Okinawan Manhole Cover Design

仲宗根　幸男 著

ボーダーインク

表紙&本文デザイン／仲田　慎平

A Picture Book of Okinawan
Manhole Cover Design

デザインマンホールとは、JIS模様やメーカー模様とは別に、各市町村が地域の特色を独自にデザインしたマンホール蓋のことをいう。私は調査や写真撮影などであちこち巡っているうちに、マンホール蓋に地域独特のデザインが施されていることに興味を持ち、それを少しずつ撮ることにした。

デザインには各自治体の市町村章やシンボル、伝統芸能、スポーツ、特産品などが刻まれ、また市町村合併等で、デザインの変更がなされたりしていることも、デザインマンホール探しの興味を誘った。

デザインマンホールの出現は那覇市が最初で、昭和五十二年といわれている。

下水道の役目は下水を浄化し、河川や海域の水質を保全することである。下水道への接続率が低い地域や自治体があり、接続率の向上をめざしている。読者がデザインマンホールに

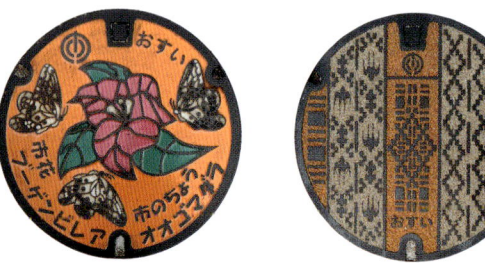

4

関心を持つことで、接続率の向上にいささかでも寄与できることを願っている。ちなみに九月十日は「下水道の日」。下水道の全国的な普及を目指して始まり、毎年九月十日に、沖縄県では土木建築部下水道課が中心となって式典が行われている。

マンホール蓋は道路や歩道に設置されているため、特に道路での撮影は車に気をつける必要があり、時には見張り役を家内にやってもらった。デザインマンホール探しや撮影には車に気をつけてください。また、当該自治体とは別の他市町村のマンホールがふいに見つかることもあり、発見の喜びを味わうこともできる。

これまで撮り溜めたデザインマンホールをまとめてみたのが本書である。読者の方々が自治体独自のデザインマンホールから、その自治体の文化や歴史等を知る楽しみを味わってほしい。

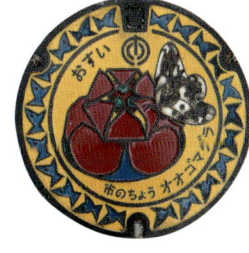 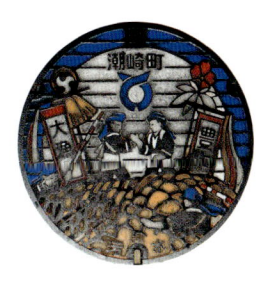

もくじ

はじめに ... 3

南部
- 南城市 ... 10
- 与那原町 ... 22
- 八重瀬町 ... 24
- 南風原町 ... 28
- 糸満市 ... 32
- 豊見城市 ... 36

那覇
- 那覇市 ... 40

中部
- 西原町 ... 46
- 浦添市 ... 48
- 宜野湾市 ... 50
- 中城村 ... 52
- 北中城村 ... 56

中部
- 沖縄市 ... 58
- 北谷町 ... 62
- うるま市 ... 64
- 嘉手納町 ... 70
- 読谷村 ... 74

北部
- 恩納村 ... 78
- 金武町 ... 82
- 宜野座村 ... 86
- 名護市 ... 90
- 本部町 ... 92
- 東村 ... 94
- 大宜味村 ... 96

離島

伊平屋村	100
伊是名村	102
座間味村	104
渡名喜村	108
粟国村	110
久米島町	112
宮古島市	116
石垣市	120
竹富町	124
与那国町	128
南大東村	132

コラム

一、他地域で見つかったマンホール	31
二、マンホール探訪記	35
三、マンホール博覧会 パビリオン①「魚」	55
四、マンホール博覧会 パビリオン②「一般的なマンホール」	73
五、マンホール博覧会 パビリオン③「綱引き」	76
六、思い出深いマンホール	81
七、マンホール博覧会 パビリオン④「足元に何かいる」	127
八、マンホール博覧会 パビリオン⑤「動物」	131
おわりに	135
おもな参考文献・ウェブサイトなど	138

 1、本書はデザインマンホールの存在する沖縄県内市町村を取り上げており、2016年3月現在で下水道接続のない地域等は割愛している。
2、動植物名等は市町村の指定名にならって記載した。

南部

A Picture Book of Okinawan Manhole Cover Design

南城市 Nanjo City

Data

市の花：ハイビスカス
市の木：リュウキュウコクタン
市花木：クチナシ
市の魚：ミーバイ（ハタ）
市の貝：チョウセンサザエ（平成19年3月1日制定）

南城市について

平成十八年一月一日に知念村、佐敷町、玉城村、大里村が合併して南城市となった。

市章は南城市のNの文字を図案化し、緑色は豊かな自然を、青色は豊穣の海を、赤色は太陽をイメージし、未来に向かって躍進する元気な市民を表現しており、和宇慶文夫氏がデザインしたものである。平成十八年十一月一日に制定された。キャッチフレーズは「海と緑と光あふれる南城市」である。

知念地区（旧知念村）

合併前の四町村のうち、旧知念村にあたる知念地区のデザインマンホールの蓋には村花であったテッポウユリ、神の島として崇拝される

10

これが旧知念の村章です

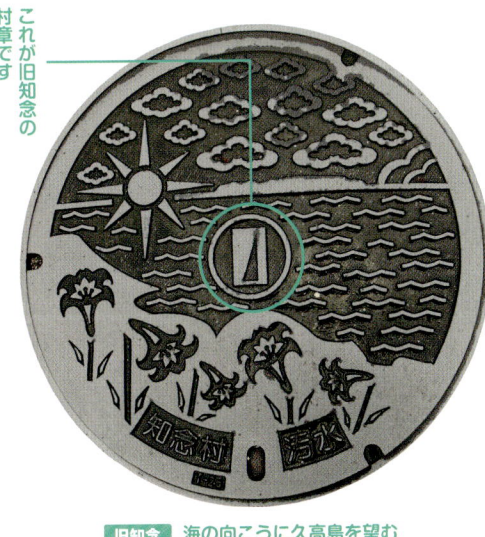

旧知念　海の向こうに久高島を望む

村章のこぼれ話

旧知念村の村章は昭和四十一年一月に制定され、世界遺産にも登録された琉球最高の聖地と言われる斎場御嶽（セーファウタキ）の巨岩と太陽御川（テダウカー）を主体に安谷屋正義氏が図案化したものである。円内の四角は斎場御嶽の巨岩を表し、内円は太陽御川、外円は村民の融和と団結のもとに限りない繁栄を象徴したものである。

久高島と、東方から上がる太陽をあしらい、中央には旧村章を配置している。

名所・斎場御嶽！

旧知念村の村章ともなった斎場御嶽（セーファーウタキ）は琉球王国時代の最高の神官である聞得大君に就任する儀式（御新下り）が行われた御嶽であり、最高の聖地と言われる所以である。また、「東廻り（アガリマーイ）の拝所でもあり、巡拝者が絶えない斎場御嶽は昭和三十年一月二十五日「県の名勝」に、昭和四十七年五月十五日「国の史跡」にそれぞれ指定される。また、平成十二年十二月二日に「琉球王国のグスク及び関連遺産群」の一つとして世界遺産に登録された後は多くの観光客が訪れるようになった。

「あがりゆう」というクェーナ（古謡）に「首里

11

城を立って与那原に出で、磯づたいに知念に進んで…」がある。「おもろさうし」(十九ノ二〇)に「知名村にはどのような人々が居るのであろうか、国王が東の知念・玉城安座真の海岸で国王の乗物を担ぐ村人どもが潮を蹴り上げ蹴り上げしながら、乗物を上げる行事があり…」とある。さらに太陽御川(テダウッカー)は国王が久高渡島の際に飲料水を補給した地であったと言われている。

これらから推察すると、国王は首里から与那原に下りて、そこから海岸沿いに御輿に乗って知念・玉城行幸と久高島行幸を行ったのであろう。その際に知名崎にあるかつて水量豊富な湧泉の清水を飲料水として利用し、補給したことがうかがえる。国王をテダと称していたことから、後世になってこの湧泉をテダウカーと呼称したのであろう。

知名崎はかつてガガジと呼称され、険しい岩山であった。平成二十七年に久高コハウ森(久高のフボー御嶽)が国指定名勝に、久高島の海岸植物群落が国指定天然記念物に指定される。

佐敷地区（旧佐敷町）

旧佐敷町にあたる佐敷地区の冨祖崎干潟に生息するトカゲハゼは、国内では中城湾沿岸と大浦湾沿岸にのみ生息し、ごく近い将来に野生での絶滅の危険性が極めて高い「絶滅危惧ーA類」に指定されている。

この貴重なハゼの生息地の環境を保全するためにも、下水道整備により生活排水を浄化し、快適な環境づくりのための水質浄化のシンボルとして、「トカゲハゼ」がマンホールの蓋にデザインされた。トカゲハゼはミナミトビハゼと同様

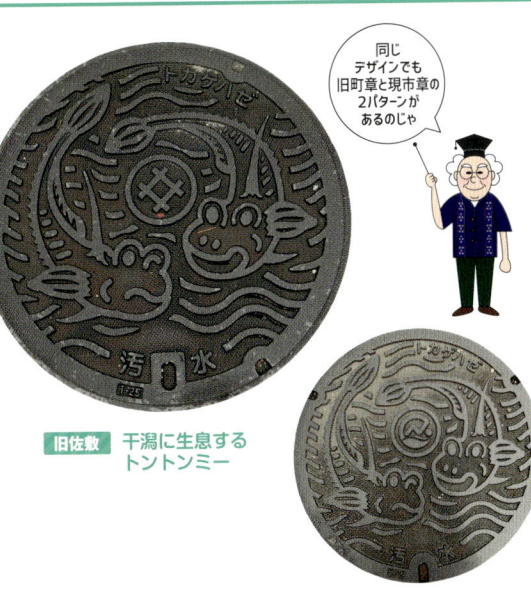

旧佐敷 干潟に生息するトントンミー

町章の
こぼれ話

同じデザインでも旧町章と現市章の2パターンがあるのじゃ

旧佐敷町の町章は「サ」を図案化したもので明治時代以前に使われていたとされているが、町章として制定されたのは昭和五十五年六月一日である。蓋の中央には町章が彫り込まれており、円は町民の融和を表現しているこのマークは字佐敷の綱引きにおける東側の旗頭の〈井桁〉でもある。

に方言でトントンミーと呼ばれていて、干潟表面の珪藻などの微小生物を摂食し、冨祖崎干潟で観察することができる。蓋のほぼ中央に市章が使われるようになったあと、南城市になった。佐敷地区には旧町章と市章が刻印された二つのタイプがある。

また、佐敷地区内のつきしろ地域は少々異なっている。「南城市の下水道」パンフレットによると、つきしろ地域は長年自治会管理の下水道施設であったが、下水処理施設の管理が平成二十一年十二月一日から市へ管理移譲され、この日公共下水道への接続式が行われた。つきしろ地域の蓋は中央に旧佐敷町の町章があり、その周囲の模様はJIS規格模様と言われているもので、一般的なマンホール蓋の一つである。地域の人々の融和と団結を表現しているようにもみえる。

13

大里地区（旧大里村）

この地区には二つのタイプがある。

デザインタイプは旧大里村の村木「リュウキュウコクタン」と村花「ブーゲンビレア」が図柄になっており、中央上側に旧村章が刻印されている。蓋の上側の縁に沿って「きれいな水で住みよい村に」と印されている。町村合併後の旧大里村字大城の蓋は二つ目のデザインと同じで、中央上側に南城市の市章があり、「きれいな水で住みよいまちに」となっている。リュウキュウコクタンは南城市の市木でもある。もう一つのタイプは沖縄県の汚水マンホールの蓋に印された県章の代わりに、旧村章が刻まれ、その周りには同心円状に配列された波頭のデザインがあり、一般的なマンホール蓋の一つである。

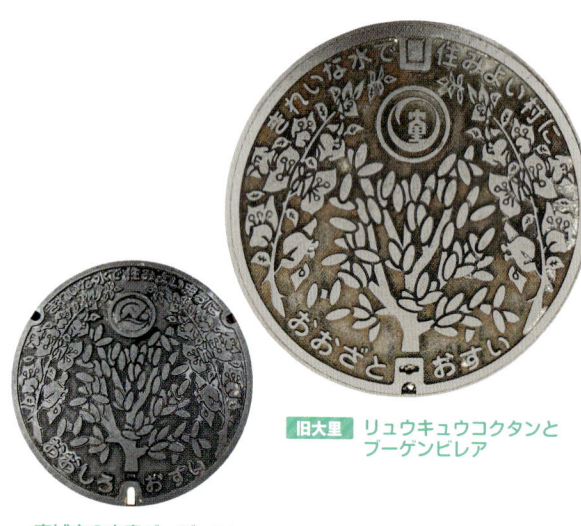

旧大里 リュウキュウコクタンとブーゲンビレア

南城市の市章バージョン

村章のこぼれ話

旧村章はサトウキビの葉で「大里」を型どったもので、昭和四十二年九月二十日に制定された。

玉城地区（旧玉城村）

この地区のマンホール蓋のデザインは地区処理場ごとに異なっていて、個性豊かなデザインになっている。いずれも旧村章が印されている。

綱引き（仲村渠区ほか）

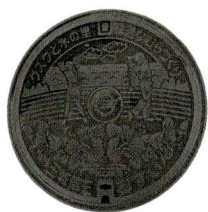
鶴とグスク（玉城地区ほか）

糸数城跡（糸数区ほか）

ゴルフ（親慶原区ほか）

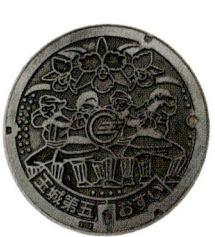
アヤグ（前川地区ほか）

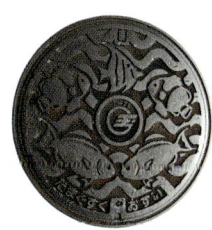
魚（奥武地区ほか）

村章のこぼれ話

旧玉城村の村章は玉城村の頭文字の「玉」を図案化したもので、村民の平和と協調と伸びゆく旧玉城村を象徴する。外円は村民の平和と協調を、円より右方へ出ている鋭角は村の躍進と発展を表現する。石松郁夫氏によるデザインである。昭和五十二年二月十五日に制定された。

詳しくは次ページから見ていくぞ

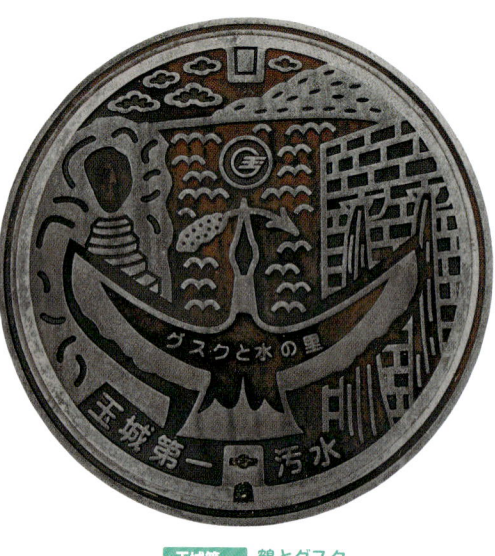

玉城第一　鶴とグスク

玉城第一地区（玉城、中山、新原）

この地区の蓋の中央には鶴が稲穂をくわえて飛んでいる様子の翼が中央部にある。その中に、「グスクと水の里」と書かれているように、右側には昭和六十年三月に環境庁（現・環境省）から「名水百選」に選ばれた垣花樋川が、左側には玉城城の城門と階段が描かれている。

名所・垣花樋川を知ろう！

垣花樋川は集落の下にあるカー（湧泉）であるために地元ではシチャンカー（下の湧泉）とも言われている。右側の湧出水をイキガー、左側のものをイナグガーと言い、男女の水浴び場だったことがうかがえる。

ほっほっほっ
面白いのー！

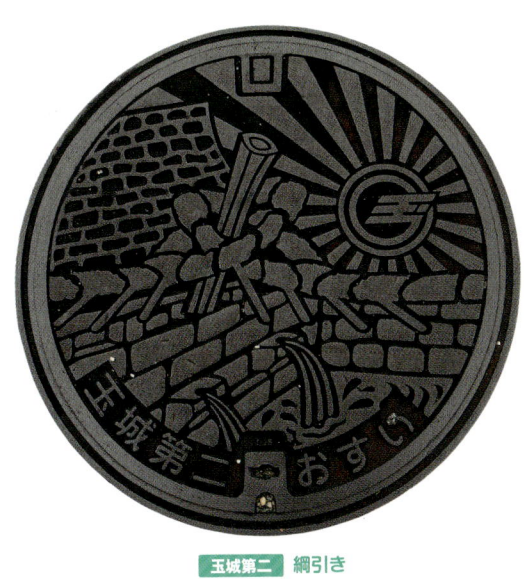

玉城第二 綱引き

玉城城の城門は主郭へ通ずる門で自然の琉球石灰岩をくり抜いて作られている。城跡は昭和六十二年八月二十一日県の史跡に指定されている。稲の発祥地と言われ、それにまつわる神田が御穂田(ミフーダ)と親田(ウェーダ)である。旧正月後最初の午(うま)の日に、親田で田植え始めの行事である「ウェーダヌウガン」が行われる。

玉城第二地区（垣花、仲村渠、百名）

この地区の蓋の中央には、この地区の仲村渠地区で毎年盛大に行われる、綱引きのカヌチ棒を差した大綱が、その下側には平成七年六月二十七日に国の重要文化財として指定された「仲村渠樋川」が、左上には垣花城跡の城壁が、右上には旧村章を太陽に見立てたデザインになっており、東方から上がる太陽が遠望できることを表

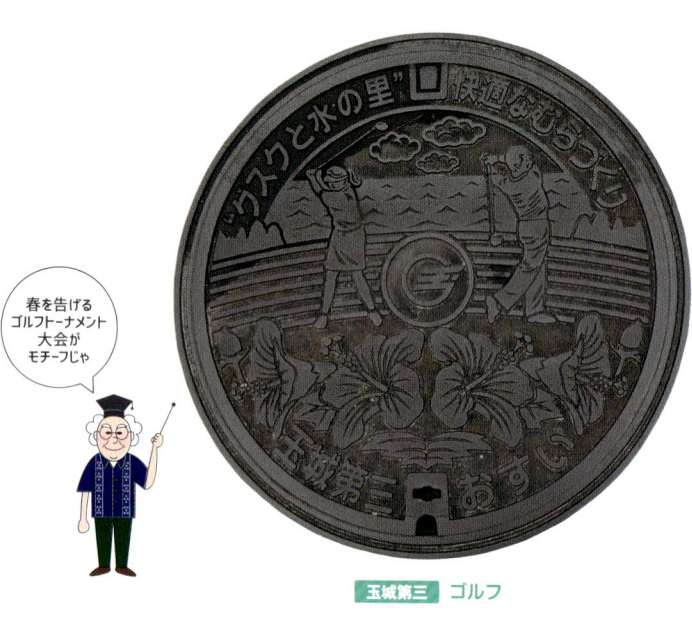

春を告げるゴルフトーナメント大会がモチーフじゃ

玉城第三　ゴルフ

稲作発祥の受水走水

現している。

仲村渠区は稲作発祥地の「受水走水」（うきんじゅ・はいんじゅ）を管理していて、収穫祭としての大綱引きは夜間に行われて独特の雰囲気をかもし出す。カヌチ棒が差し込まれると同時に綱引きが始まる。仲村渠樋川は大正元年から翌年にかけて、貯水槽、広場、石畳の道、赤瓦の共同風呂などが造られたという。垣花城跡は昭和五十六年六月十五日県の史跡に指定されている。

玉城第三地区（親慶原、喜良原）

この地区の蓋には青い空と海、さらに南国を彩るハイビスカスの花が描かれており、その中

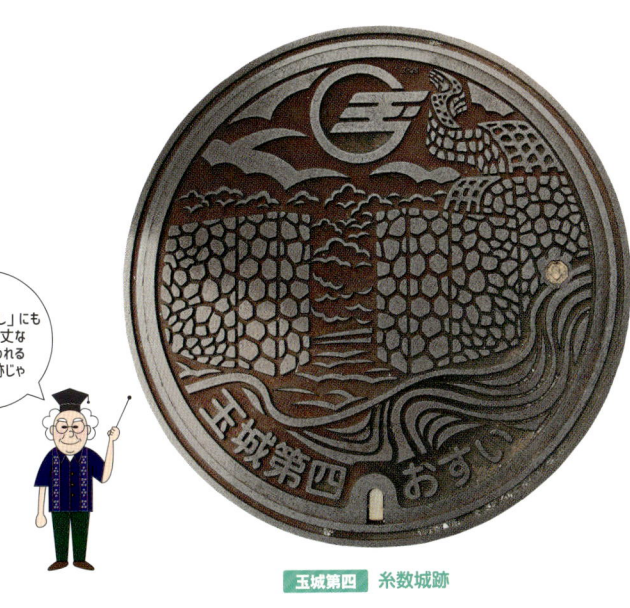

「おもろさうし」にも立派で頑丈な城とうたわれる糸数城跡じゃ

玉城第四 糸数城跡

央には青い空の下で、男女がゴルフをしている図柄になっている。

この地区には有名なゴルフ場があり、ここで女子プロゴルフのダイキンオーキッドレディストーナメントの試合が最初に行われることから、ゴルファーが描かれている。ハイビスカスは南城市の市花でもある。

玉城第四地区（糸数、屋嘉部、富里、当山、志堅原、堀川）

この地区の蓋には、最も高い所に位置し、昭和四十七年五月十五日国指定史跡に指定された「糸数城跡」の城壁が描かれている。

この糸数城は玉城按司が玉城城を守るために、三男を糸数城主に任じて築城させたと伝えられ、十四世紀中頃といわれている。糸数城主の住居跡が城のトゥン（殿）となって、毎年旧暦五

19

月十五日と六月十五日に按司の子孫や糸数区民が祭祀を行っているという。

イ（ハタ）である。

玉城第五地区（前川、船越、愛地）

前川集落の最も有名な伝統芸能である「アヤグ」と、船越・愛地での栽培が盛んな観葉植物が描かれている。

アヤグは明治五年に前川村の若者達の勇姿を宮古のアヤグ節に赤嶺治八翁が振り付けしたものであるという。

船越・愛地は県内でも観葉植物の本土出荷が最も多い地域であるといわれる。玉城奥武地区は昔から漁業の盛んな集落で、漁業で生計を立てて、子供たちを学校に通わせていた。奥武島の子供たちがそのことを忘れないようにと魚がデザインされたそうである。南城市の魚はミーバ

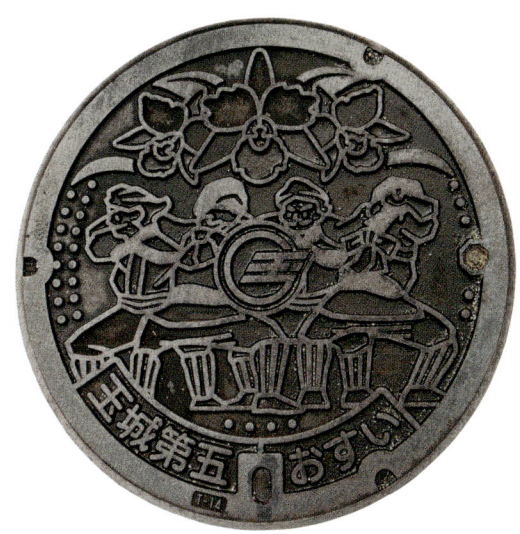

玉城第五 前川のアヤグと観葉植物

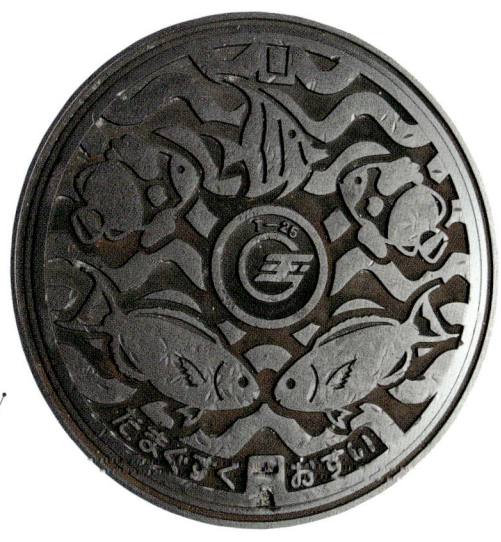

玉城第五 漁業で生計を立てていたことを象徴する魚のデザイン

与那原町 Yonabaru Town

Data

町花木： デイゴ
町　木： リュウキュウコクタン
町　花： ハイビスカス
（昭和60年2月4日制定）

与那原町について

戦前まで旧大里村の一つの字であったが、戦後の昭和二十四年三月三十一日旧大里村より分離して四月一日から町制を施行した。「太陽と緑のまち　よなばる」がキャッチフレーズ。

カナチ棒と旗頭

デザインマンホールの蓋には東西の綱を結合しカナチ（カヌチ）棒を挿入する場面と左右に旗頭が、また上側には町章と浮雲らしいのが描かれている。

旗頭は毎年作り変えられるという。大綱引きは四百年余の歴史があるといわれ、与那原の伝統文化を象徴し、沖縄での三大綱の一つである。与那原町の綱引きは戦前旧暦六月二十六日に行

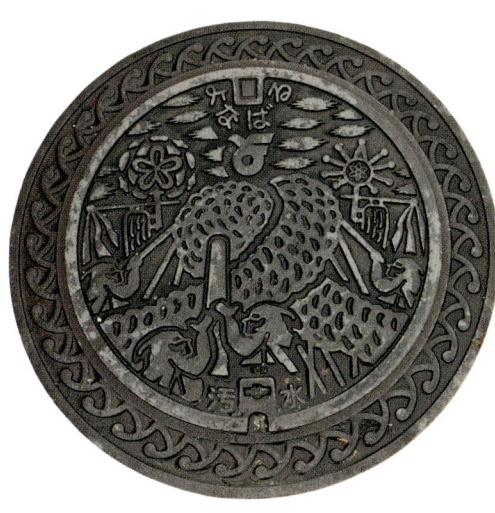

与那原町 旗頭もかわいい

町章のこぼれ話

町章は与那原町の頭文字の「よ」を波と飛鳥のイメージに図案化し、町の融和・平和団結を表現するとともに産業の雄飛発展を力強く象徴する。昭和四十八年四月一日に制定されている。

われていたが、戦後二六日以降の日曜日に開催が行われるようになった。それで二十六日当日には豊年と健康祈願及び綱引きの「日延べの御願」が行われる。綱の特徴として綱の途中に枝綱があることとカナチ縄の巻き方が他市町村の綱と異なることであると言われる。

与那原大綱引きはすべてが連続した動きであるのが特徴であるという。綱の上に支度（したく）が乗り、ドラの音を合図に担ぎ棒で綱を上げる体制に入り、鉦鼓の音で「サー」という掛け声をかけて、綱を担ぎ上げる。そして、東西の綱を寄せ合い、雌雄のカナチを六尺棒で結合させ、カナチ棒が入ると同時に綱を引く、といった流れである、という。与那原町立綱曳資料館があり、綱引きの歴史を知ることができる。

八重瀬町 Yaese Town

Data

町　花： マリーゴールド
町　木： リュウキュウコクタン
町花木： ヒカンザクラ
町　魚： トビウオ（方言名トゥブー）
　　　　（平成19年9月5日制定）

八重瀬町について

平成十八年一月一日に、東風平町と具志頭村が合併して八重瀬町となった。「大地の活力とうまんちゅの魂が創り出す自然共生の清らまち」をキャッチフレーズにしている。

旧具志頭村

旧具志頭村の時代にデザインされたマンホールが港川近くの雄樋川沿いの県道にある。その蓋には港川で毎年行われるハーレーでサバニを漕ぐ様子を正面から見た図柄があり、その右側には旧具志頭村の村魚であったトビウオが描かれている。トビウオはまた八重瀬町の町魚でもある。上側には村花であったテッポウユリ、村花木であったブーゲンビレアと旧

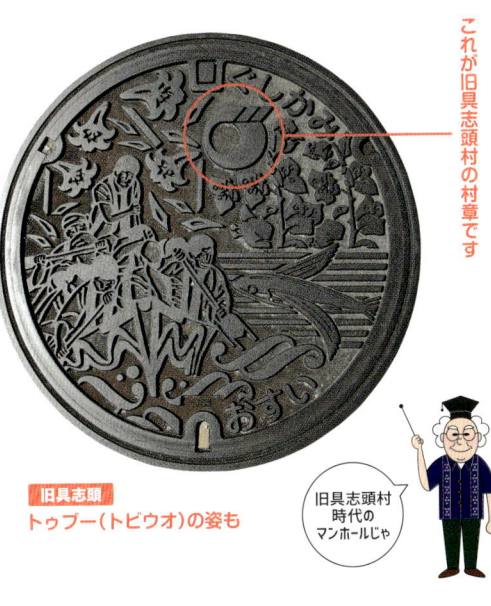

これが旧具志頭村の村章です

旧具志頭
トゥブー（トビウオ）の姿も

旧具志頭村時代のマンホールじゃ

町章のこぼれ話

八重瀬町の頭文字の「八」を八重瀬岳に見立て、鮮やかな緑色で「大地の活力」を表現し、中心の「丸」は融和で町づくりに取り組む町民の心を、明るく温かみのあるオレンジ色で「うまんちゅの魂」を、さらに「水色の部分」は八重瀬岳のふもとで繁栄する「自然と共生する清らまち」八重瀬町を表現しており、中村優美さんがデザインしたものである。平成十八年六月二十一日に制定された。

具志頭村の村章が印されている。旧具志頭村の村章は「ぐ」を鳥の形に図案化したもので、昭和五十年九月十日に制定された。

ハーレーとトビウオ

港川は糸満から移住してきた人々の集落であるため、舟こぎ競漕を糸満同様にハーレーと呼んでいる。ハーレーはバレーと同義で本来はハレのことであろう。古語のハレ（晴れ＝正式、表向き）は古語のケ（褻＝正式・公式でないこと、ふだん、日常）と対義語であり、池宮正治氏によると、ハレは要するに「祭祀の時」のことであるという。すなわち、ハーレーはハレに由来すると思われる。トビウオが胸びれを使って飛ぶ滑空時の高さは三〇メートルにも及ぶといい、一回の飛翔距離は三〇〇メートルにも及ぶといい、港川での漁業の始

まりはトビウオ漁であったという。

シーヤーマーと牛の図柄

旧具志頭村時代のもう一つの蓋はその中央に旧村章があり、その周りは四分割され、第一、第三象限には牛が、第二、第四象限には集団舞踊のシーヤーマーが描かれている。

小型バージョンは二分割され、上半分には旧村章とシーヤーマーが、下半分には牛が描かれている。シーヤーマーは椎山のことで、イタジイ、マテバシイなどが昔自生していて椎の実を採って食べていたという。

旧具志頭村の後原をはじめ八重瀬町は酪農や和牛繁殖、肉用牛飼育などの盛んな地域として知られている。町では畜産共進会が開催されており、平成十八年の畜産出額は沖縄県内ラン

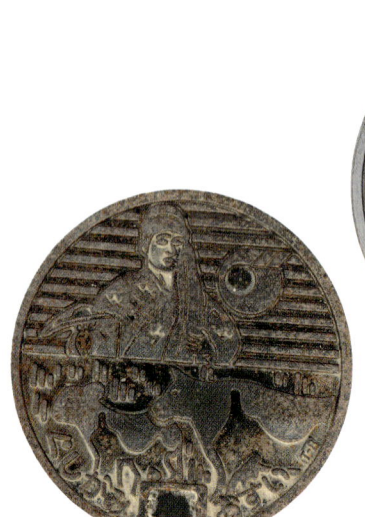

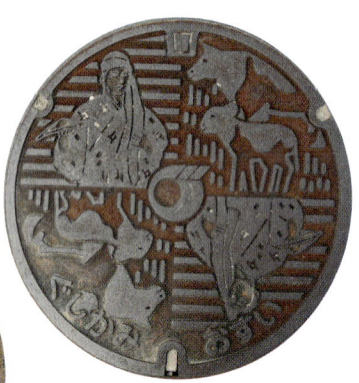

旧具志頭
シーヤーマーと牛の図柄が2パターンある

26

クが三位であった。町指定伝統無形民俗文化財のシーヤーマーは椎の実を拾い集める所作を舞踊化して表現したものと言われ、百七十年ほど前から伝わる新城独特の集団舞踊として幾世代にもわたって継承されてきた。保存会も結成され、地域文化への寄与で平成十九年には沖縄県文化協会から表彰された。

下水道への接続を！

八重瀬町誕生後のマンホールの蓋の図柄としては蓋の中央に市章が印され、その周囲に同心円状に配列された波頭があるJIS規格模様のものがあり、その他に模様の異なるものが四つある。港川漁港近くの公園には下水道への接続を呼びかけるアピール板が張り付けられていて接続率の向上をめざしている。

> 八重瀬町になってからはJIS規格のものが使われているのじゃ

八重瀬

下水道への接続で、きれいな川や海の再生を！
八重瀬町役場

港川漁港近くの公園にあるアピール板

 # 南風原町 Haebaru Town

Data

町　木：リュウキュウコクタン
町　花：ブーゲンビレア
　　　（昭和57年12月25日制定）

南風原町について

南風原町は琉球絣の産地として有名であり、昭和五十二年に琉球絣事業共同組合によって「琉球かすりの里」が宣言された。

南風原町は昔から、琉球絣の産地として知られ、その九〇パーセントを生産している。「かすり」という呼称は、糸の染め方・織り方の加減によって、図柄のエッジがわずかにかすれたようになることに由来するという。

かすりの魅力は手織りによる微妙な味わいのある模様や色彩が浮かび上がるところで、織り上がった布を後から染める「後染織物」とは異なる。

昭和五十八年には「琉球かすり」が当時の通産大臣指定「伝統的工芸品」に選ばれる。平成十年には「南風原花織」が県条例に基づく伝統工芸製

28

南風原町 種々のかすり模様が描かれている

町章のこぼれ話

南風原の頭文字「は」を鳥の雄飛するイメージに図案化し、町の平和と融和団結、協力を表現し、併せて産業文化の躍進伸張を象徴したもので、また「波頭」は悠久に流れる国場川を意図している。昭和四十六年四月十八日制定された。「ともにつくる黄金南風原の平和郷」をキャッチフレーズにしている

マンホールもかすり模様

下水道事業も昭和五十四年度から着手し、デザインマンホールの蓋にも絣の柄をモチーフに中央には町章が印されている。

次頁の最新の蓋には「かすりの里はえばる」とあるように、絣織の場景と町花のブーゲンビレアが、さらに蓋の縁周りにも絣の柄が描かれている。親しみやすい下水道にするため平成七年度からこのデザインに変更されたが、「はえばる」とあるので、町章は記されていない。平成十六年に「琉球絣」と「南風原花織」が南風原町無形文化財に指定される。

ちなみに琉球王府の「御絵図帳」（みえずちょう）品に指定される。平成十六年に「琉球絣」と「南風原花織」が南風原町無形文化財に指定される。

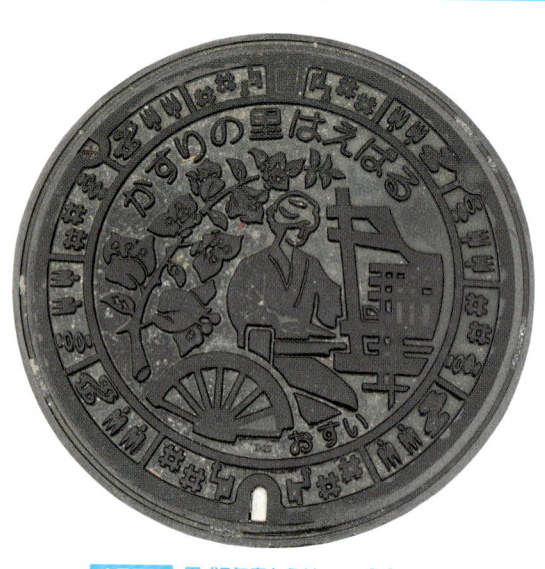

南風原町　平成7年度からはこのデザインに

う）は絵図奉行によってまとめられた図案集で、その中には六〇〇種もの多彩な図柄があるという。昭和五十三年に大城カメさんが、平成元年には大城廣四郎さんが現代の名工に選ばれている。

他地域のマンホール蓋が見つかることも

南風原には、その他に模様の異なる蓋が二つある。

ところで、デザインを探す楽しみの一つが、他地域のマンホールが見つかることである。例えば、闘牛がデザインされた旧具志川市の蓋や、パインなどがデザインされた金武町屋嘉の蓋が南風原町の歩道で見つかったりする。これも一つのエコか、それとも仮の利用だろうかと思った。

30

他地域で見つかったマンホール

マンホール蓋を探し歩いているとすっかり足が棒になってしまうが、その地域のものではない蓋を発見した時には、その喜びが疲れを癒してくれる。読谷にあるはずの一般的マンホール蓋や石垣市の赤馬デザインマンホール蓋を那覇市で見つけたこともある。また、久米島で浦添市の一般的なマンホール蓋と止水栓、そしてコザ市時代の一般的なマンホール蓋を見つけた時には、新種を発見したという喜びがわいてくるのを感じた。気分は爽快、それまでテクテク歩いてきて疲労気味の体と心をも癒してくれたものである。しかし、発見の喜びをかみしめながらつくづくと蓋を眺めて喜んでいる姿は、周辺を歩く人々にとってはとても奇異に映るようではあるが……。こうして、別の地域で発見されるマンホール蓋はほかにも多々あるはずだ。読者の方々も散策しながら、人の目を気にせずに発見の喜びを味わってほしいものである。

糸満市 Itoman City

Data

- 市　木：ガジュマル
- 市　花：ニチニチソウ
- 市花木：ブーゲンビレア
- 市　魚：タマン

（昭和57年12月25日制定）

糸満市について

昭和三十六年十月一日に糸満町、兼城村、三和村が合併して新たな糸満町がスタートした（三和村は昭和二十一年四月四日に真壁、喜屋武、摩文仁の三村が合わさってできた）。昭和四十六年十二月一日に、合併十周年を迎えて、市制を施行し、糸満市が誕生した。糸満市は「ひかりとみどりといのりのまち」を基本理念としている。「旧暦文化のまち」としても知られている。

ウミンチュの漁網をアレンジ

中央に市章が描かれており、ウミンチュ（海人）のまちとして知られる糸満は漁業が盛んであることから、市章の周囲には漁網をアレンジしたデザインがされている。

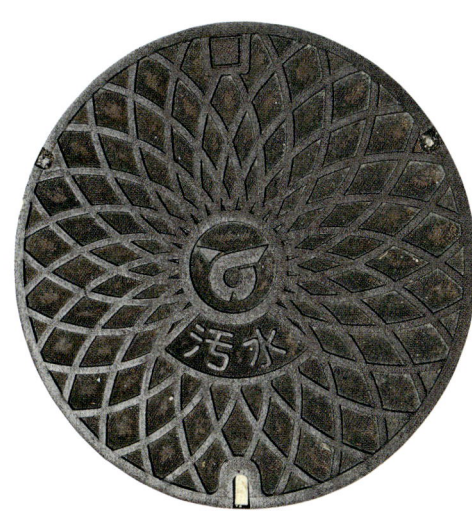

糸満市 美しい幾何学模様が糸満の特徴

市章のこぼれ話

糸満の「いと」を図案化したもので、市民の希望・融和・団結を円形で、市の飛躍的発展を羽ばたく両翼で表徴したものである。佐藤定夫氏によってデザインされた。

明治十七年に糸満海人の玉城保太郎氏がミーカガン（水中眼鏡）を考案して、採貝漁業や追込網漁業の伸展に大きく寄与したという。また明治二十五年に金城亀氏がアギヤー（追込網漁法）を考案し、グルクンなどの磯根魚類の漁獲能力が大きく向上したという。旧暦五月四日（ユッカヌヒー）には漁民のお祭であるハーレー（海神祭）が盛大に行われる。

糸満大綱引きのシタク

潮崎町のデザインマンホールの蓋には雄綱と雌綱の上に乗った支度（シタク）が綱の中央で対峙している様子が旗頭とともに描かれている。カラーバージョンもある。

糸満大綱引きは毎年旧暦の八月十五日に行われ、豊年と大漁祈願、家内安全、無病息災を祈る

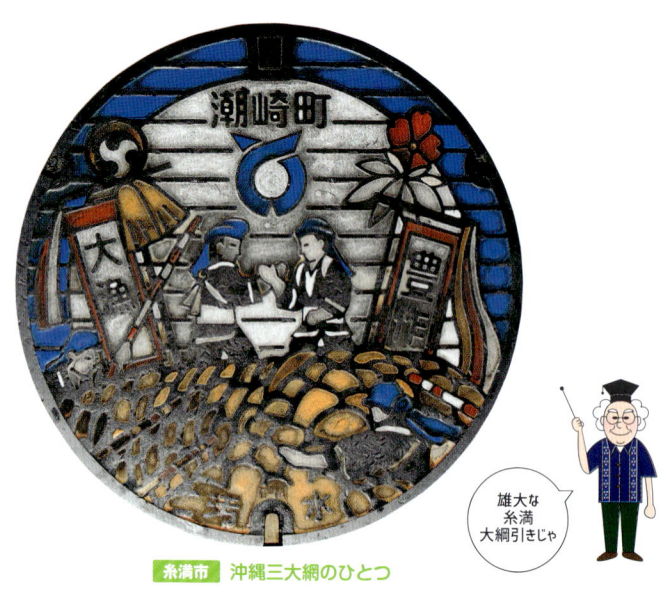

糸満市　沖縄三大網のひとつ

雄大な糸満大綱引きじゃ

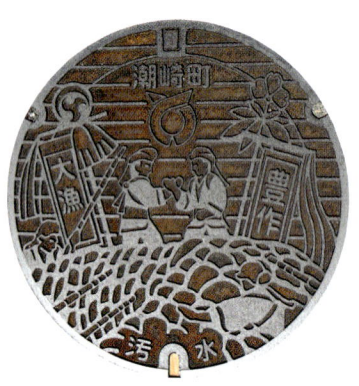

モノクロバージョンも

神事であり、南北に分かれた雌雄の綱の結合で実りを予祝し、勝負の結果で吉凶を占う行事であるという。競技時間は三十分で、勝敗は十メートル引いた方が勝ちとなる。制限時間内に十メートル引けない時には二メートル以上引いた方が優勢勝ちとなり、双方が二メートル以上引けない場合には引き分けるというルールがある。沖縄三大綱の一つである。

Column 2

マンホール探訪記

マンホール蓋を探してぶらぶら歩いていると、歩行者から「何か落とし物でもしましたか」と声をかけられることがある。時に変人に見られたり、あろうことか泥棒と間違われたり、犬に吠えられたりすることさえ。そうした時は、「発見の喜びを味わうのも至難の業だ」などと思ったりするものである。カメラを肩にかけて、見つけた蓋をしみじみと眺めたり、撮影のために表面の砂粒などを掃いている姿は、ほかの人の目には妙な姿に映るものらしい。それで、わざわざ近寄ってくる人もおれば、はたまた「バカじゃないか」という顔つきで眺める人もおり、さらには「良い趣味をお持ちですね！」などと、いったい褒めているのかからかっているのか分からない人情の持ち主もいたりする。人も見る目も多種多様だとマンホール散策ではつくづく気付かされたものである。犬も歩けば棒に当たるとはこの事かと！でも路上の芸術を見て歩くのも悪くないと言い聞かせつつ！新しい蓋を見つけては自画自賛の日々である。

豊見城市 Tomigusuku City

Data

市　木：リュウキュウコクタン
市　花：ブーゲンビレア
　　　　（昭和56年11月1日に村木・村花として制定）

豊見城市について

豊見城間切から明治四十一年四月一日に豊見城村となり、昭和五十一年には日本一人口の多い村となった。平成十四年四月一日に、日本一人口の多い村のまま、単独で村から市になった。現行の地方自治法に基づいて村が市となった初めての例であった。

「ひと・そら・みどりがつなぐ 響むまちとみぐすく」をキャッチフレーズにしている。

四方八方に飛び立つトンボ

デザインマンホールの蓋は、とんぼの幼虫（やご）が生息できる水質を保つようにと、とんぼが四方八方に飛び立つ様子が図案化されている。蓋の中央には「市章」が印され、その周りに波頭

市章のこぼれ話

「とみぐすく」の「と」を三つ配して「とみ」とし、積み重ねた円形は城（ぐすく）を表し、組み合わせた三つの円形はそれぞれ中心への対話をもたらし「調和・団結」を表す。外に伸びる矢印は無限への広がり「発展」を示し、全体の図案は「調和と限りない発展を築きあげる」豊見城市民の意気を示す。平成十四年四月一日制定された。

豊見城市 よく見るとトンボがたくさん

が描かれている。

トンボは沖縄語でアーケージュー（日本古語アキヅから）と言い、戦後の水田とコンクリート張りでない河川があった頃は多種多様なトンボが見られたが、市の下水道課が指摘するように「ふるさとの思い出にのこる」代表的な昆虫である。

豊見城市 夏らしいデザイン

市内のビーチを表現

　豊崎のデザイン蓋の中央には市章があり、その下には豊崎美らSUNビーチと水路、豊崎の一部が、ビーチの沖合にはザトウクジラとヨットが描かれている。豊崎美らSUNビーチは平成二十二年五月にオープンし、全長約七〇〇メートルで県内最大級の大きさである。ザトウクジラは一月から三月にかけて慶良間諸島海域に現れ、ホエールウォッチングが盛んに行われる。

38

那覇

A Picture Book of Okinawan
Manhole Cover Design

那覇市 Naha City

Data

- **市　花：** ブーゲンビレア（昭和58年10月1日制定）
- **市　木：** フクギ（昭和58年10月1日制定）
- **市花木：** ホウオウボク（昭和58年10月1日制定）
- **市の魚：** まぐろ（平成22年8月17日制定）
- **市の蝶：** オオゴマダラ（平成26年2月28日制定）

那覇市について

那覇の方音「ナーファ」「ナファ」は、伊波普猷氏によると、ナバ（漁場）に由来するという。那覇は昔、浮島とも言われ、浮島の入江には国場川、安里川、久茂地川の三河川から栄養塩類が運ばれて、よいナバをなしていたのであろう。ナバを強調してのことであろうか、側溝のセメント蓋にも魚が描かれ、ローマ字でNAHAと書かれている。ナハ、ナファ、ナワ、ナバなどと呼称されていたが、読み方を「ナハ」ということに統一することが日本放送語審査委員会で昭和九年三月十二日に決定された。

大正十年五月二十日首里区が市制施行で首里市となる。昭和二十八年十月一日真和志村が市制施行で真和志市となる。昭和二十九年九月一日首里市が小禄村とともに那覇市と合併する。

市章のこぼれ話

「ナハ」の字を円形に図案化し、発展していく那覇の姿を表しており、大正十年十二月十九日制定された。

那覇市 全部で69匹の魚がいます

全国初のデザインマンホール

三年後の昭和三十二年十二月十七日には真和志市が那覇市と合併して現在の那覇市域となる。「夢をかたちに、笑顔をくらしに、元気をまちに。なはが好き！　みんなで創ろう子どもの笑顔が輝くまち」をキャッチフレーズにしている。

デザインマンホールは中央の市章の周りに魚の連続模様が描かれており、生活排水等を下水道施設で浄化し、魚が住める環境にしていくという趣旨のデザインであるという。那覇市のデザインマンホールが、全国に先駆けて、元市職員によってデザインされ、それが地域独特のオリジナルデザインマンホールの始まりで、昭和五十二年であると言われている。

那覇市 平成26年に指定された市蝶オオゴマダラ

水洗化率ほぼ百パーセント

那覇市は平成十九年度国土交通大臣賞（いきいき下水道賞）を、水環境回復創出部門で〝美しい川〟をめざして〜安謝川の浄化〜"の事例名で、受賞している。下水道への接続促進に取り組んできた結果として、水洗化率がほぼ百パーセントに達しているという。その他に模様の異なる蓋が十ほどもある。

多様なカラーマンホール

平成二十六年二月二十八日の市の蝶の制定を受けて、壺屋のデザインマンホールのカラーバージョンにブーゲンビレアとともにオオゴマダラの図柄が取り入れられた。

那覇市 うふシーサーとブーゲンビレア

壺屋のシンボル・うふシーサー

　平成十四年四月三日に「四月三日をシーサーの日」にして、全県・全国に広めようと宣言された。平成二十五年二月九日に「壺屋うふシーサー」が設置された。このシーサーは高さが三・六二メートル、重さが約三トンあるという。壺屋は焼物(ヤチムン)の町として知られ、シーサー文化の発信地にふさわしくこの巨大シーサーが出現した。壺屋は「焼物の生産地」を指す語で、それが地名になったという。まさに「焼物文化発祥の町」である。

鮮やかな色彩にうっとりしてしまうのじゃ

那覇市 かすり模様が全面に出た個性的なデザイン

伝統工芸の首里織も

首里織をデザインにしたマンホール蓋のカラーバージョンも首里の金城町に出現している。首里織の名称は昭和五十八年に当時の通産省伝統産業法指定申請の際に命名されたという。首里織は紋織りから絣に至るまで織られるのが特徴で、伝統的な技術・技法から首里絣、首里花織、首里道屯織、首里花倉織、首里ミンサーに分類されるという。

沖縄の個性が生んだ傑作じゃ

中部

A Picture Book of Okinawan
Manhole Cover Design

西原町 Nishihara Town

Data

町　木： ガジマル
町　花： ブーゲンビリア
町花木： サワフジ（さがりばな）
　　　　（昭和55年3月2日制定）

西原町について

西原村から、昭和五十四年四月一日の町制施行で、西原町となる。町づくりの理念は平和・共生・躍動。「文教のまち西原」がキャッチフレーズ。

町内にある運玉森は「西原富士」とも呼ばれている。内間御殿は第二尚氏王統始祖の金丸（のちの尚円王）が内間地頭であった時の住宅跡に、尚円王没後百九十年も経って建てられた神殿で、平成二十三年二月七日国指定文化財（史跡）に選定された。御殿の敷地内には戦前まで石碑があったが、戦争で破壊されて石碑の一部と台座だけが残った。元文三（一七三八）年六月十二日に建立されたという。この敷地内のサワフジは樹齢四七〇年以上と言われ、平成二十四年五月八日町の天然記念物に指定される。

西原町 町にある内間御殿のサガリバナ

美しいサガリバナ

西原町のデザインマンホールの蓋は町のシンボルである運玉森をシルエットにブーゲンビレアと内間御殿のサワフジ（サガリバナ）が描かれており、蓋の中央には市章が印されている。

サガリバナはマングローブ林背後の湿地や内陸部の河川沿いの湿地などに生育するが、今日では道路沿いにも植えられ、その美しい花が夏の夜を彩る。地元ではサワフジをジンカキーギー（銭掛け木）と呼ぶが、花の形状が鳩目銭をぶら下げているのに似ていることに由来するという。内間御殿のサワフジに命や平和の尊さを託した「サワフジの詩（うた）」の歌碑が町立図書館敷地内に建立され、平成二十七年七月十七日に除幕式が行われた。もう一つの蓋はJIS規格模様で町章がないものである。

町章のこぼれ話

西原町の頭文字の「西」を図案化し、円は町民の融和団結を、翼は町勢の雄飛発展の姿を表現し、輝く西原町の将来を力強く象徴したものである。西原村章として昭和四十三年七月三日制定されたが、町制施行後も継承された。

浦添市 Urasoe City

Data

市　木：ホルトノキ
市　花：オオバナアリアケカズラ
市花木：オオゴチョウ
　　　　（昭和49年12月4日制定）

浦添市について

浦添村が昭和四十五年七月一日に市制施行して浦添市となった。浦添市は「てだこの都市（まち）」とも呼ばれる。「てだこ」は「太陽の子」を意味し、琉球第二の王統として栄えた英祖王の敬称であるという。「すべての市民が太陽のように光り輝き、世界に開かれた活力あふれる平和で豊かな住みよいまち」を都市像にしている。「太陽とみどりにあふれた国際性ゆたかな文化都市」をキャッチフレーズにしている。

「てだこ」の顔をみつけよう

市のデザインマンホールの蓋は中央に市章が印され、その市章を取り巻く円から太陽の光線が放射状に描かれている。放射光模様の中に蓋

市章のこぼれ話

「ウラソエ」の四文字を円形に図案化したもので、「ウ」の字の出部は「無限に進展する平和郷」浦添市を象徴している。浦添村章として昭和三十六年六月二十六日制定されたが、市制施行後も継承された。

浦添市 浦添城を居城とした英祖王にならい「てだこ」は市のシンボルになっている

の中心をして正三角形の各角に「てだこ（太陽の子）」が印されている。「てだこ」のかわいい笑顔が浦添市の発展を誇っているようにみえる。毎年、盛夏に「てだこまつり」が一大イベントとして催される。さらにその他に波頭模様の蓋と斜線模様の蓋がある。浦添は古くは「うらおそい」と呼ばれ、琉球王国が中世に浦添で生れ、琉球国中山の王宮であった浦添城は十五世紀初期に尚巴志によって滅ぼされ、王宮は首里城に移された。

一般的なマンホール蓋もあるのじゃ

宜野湾市 Ginowan City

Data

市　木：リュウキュウコクタン
　　　　（平成8年2月9日制定）
市　花：キク（昭和50年12月9日制定）
市花木：サンダンカ
　　　　（昭和50年12月9日制定）

宜野湾市について

宜野湾村から、昭和三十七年七月一日の市制施行で、宜野湾市となる。宜野湾は「ねたての都市（まち）」とも呼ばれ、「ねたて」は物事の根元または共同体の中心を意味している。「市民が主役の「ねたて」の都市・ぎのわん」をキャッチフレーズにしている。宜野湾は二十一世紀をリードする限りない発展を秘めた沖縄県の中核都市として、宜野湾市を象徴する市民の合言葉として「ねたての都市ぎのわん」を使っているそうである。

波打つはごろも模様

市のデザインマンホールの蓋はその中央に市章が印され、その周りには「はごろも」が描かれている。それは天女が「森の川」に降り立ち水浴びを

宜野湾市 天女のはごろもをイメージさせるデザイン

市章のこぼれ話

「ギノ」を図案化したもので、「ギ」で躍進の翼を形どり、円で湾を表し、協力の和と平和を表す。市章は昭和四十一年七月一日制定されたが、翌年の四十二年六月十七日再制定されたという。

していたという「はごろも伝説」があり、天女が身に着けていたという「はごろも」に由来する。

「はごろも伝説」によると、奥間大親と天女との間に生まれた男子が成長して、勝連按司の娘を妻にする。のちに浦添の按司となり、中山王察度になったという。十三世紀、察度王の時代に宜野湾は琉球の根（ねのしま、ねたて）と呼ばれ、政治・経済・文化の中心地であったという。毎年「宜野湾はごろも祭り」が行われる。

さらに逆Y字型模様がデザインされた蓋とJIS規格模様の蓋がある。

JIS規格のものもあるのじゃ

中城村 Nakagusuku Village

Data

村　木：リュウキュウコクタン
村　花：ハイビスカス
村　魚：イジュキン（モモイトヨリ）
　　　　（昭和64年4月23日制定）

中城村について

中城城跡があり、昭和三十年一月二十五日に県指定の名勝に、昭和三十七年六月七日には県指定の史跡及び建造物に、昭和四十七年五月十五日には国の史跡に指定され、平成十二年十二月二日には「琉球王国のグスク及び関連遺産群」の一つとして世界遺産に登録されている。「豊かな歴史と自然に彩られた田園文化の村、とよむ中城」をキャッチフレーズにしている。

琉歌の刻まれたユニークなデザイン

中城城から月を眺めた琉歌が村のデザインマンホールの蓋に書かれていて、とてもユニークである。蓋には大型版と小型版がある。大型版には城門とハイビスカスが、その城門には吉の浦

村章のこぼれ話

円は村民の和を表し、巴は護佐丸の紋を型どったもので誠実を表し、「中」の字と突出部は村名と村の発展を表現している。昭和五十四年三月十日制定された。

中城村 「美しい入り江」として吉の浦を歌った

小型版

吉の浦公園内の石碑にも

の砂浜と月が描かれ、さらに国頭親方朝斉（一六八六―一七四七）が詠んだ琉歌「とよむ中城 よしの浦のお月 みかげ照り渡て さびやないさめ」（世に名高い中城城から吉の浦を眺めると月が美しくてりわたり、何と平和なことか、とても災などあろうはずがない）が書かれている。吉の浦公園入口の石碑にもこの琉歌が刻まれており、詠み人は国頭親方朝斉となっている。小型版にも同じ琉歌が書かれており、さらに村章と波

模様が描かれている。

国頭親方朝斉は進貢正使や慶賀使などを務めた有能な官僚であるとともに歌人でもあったという。「おもろさうし」に、「中城吉の浦　吉の浦の　珍らしや（美しいことよ）　今日から　しばしば　見らに（見たいものだ）　又　屋宜の浦の吉の浦の」とある。「よしの浦」は美しい入り江の意味だといい、屋宜の浦の美称だという。

吉の浦海岸は直立式護岸が建設される以前はオカヤドカリ類が群れる美しい砂浜だったといい、自然と共生する海岸をめざして県によるエコ・コースト事業も行われた。中城城は永享十二（一四四〇）年頃までに護佐丸によって築かれたという。護佐丸・阿麻和利の乱が長禄二（一四五八）年に起こり、ともにその年に滅亡するが、その争乱の原因については諸説があるといわれる。この故事は組踊の題材にもなり、組踊

「護佐丸」がある。この組踊は中城村の伝統芸能でもある。

Column 3

マンホール博覧会
パビリオン❶-「魚」

カツオ(本部町)

魚(旧玉城)

トントンミー(旧佐敷)

カジキ(与那国町)

北中城村 Kitanakagusuku Village

Data

- 村　花：ラン（デンドロビュウム、カトレア、コチョウランなどが代表的なラン）
- 村　木：リュウキュウコクタン
- 村花木：ブーゲンビリア
（昭和61年5月20日制定）

北中城村について

終戦後、中城村は米軍施設で南北に分断されて行政運営に支障をきたし、昭和二十一年五月二十日やむなく中城村北部の十二行政区が分離して北中城村が誕生した。

北中城村は「平和で活力ある田園文化村」をキャッチフレーズにしている。村には昭和四十七年五月十五日に指定された国指定重要文化財の「中村家住宅」があり、十九世紀初期頃に建てられた豪農の住宅である。

村花であるランはまた村の特産品としても出荷されている。

特産のランで華やかに

村のデザインマンホールは中央に村章が印さ

北中城村 洋ランの産地

村章のこぼれ話

「北」「中」を図案化したもので、円は村の平和と協調、団結を表し、左右の北と中の文字は、村民の英知を集結して、未来に向かって飛躍発展する姿を象徴したものである。昭和五十五年五月二十日制定された。

れ、その周りにはランがデザインされている。平成二十四年には洋ランの収穫量が中部で上位三市町村の中に入るほどラン栽培が盛んである。

沖縄市 Okinawa City

Data

市　木：ビロウ
市　花：ハイビスカス
　　　　（昭和49年10月26日制定）

沖縄市について

元々はコザと呼ばれていたが、その由来は越来村の胡屋地区を米軍がKOZAと呼び、一般の人々もコザと呼ぶようになったなど、諸説ある。

昭和三十一年六月十三日越来村からコザ村へ名称を変更し、また同年七月一日コザ村が市制を施行してコザ市が誕生した。昭和四十九年四月一日コザ市と美里村が合併して沖縄市が誕生した。「国際文化観光都市」をキャッチフレーズにし、平成二十年五月五日に「こどものまち」を宣言してシンボルマークも作成している。

市の象徴、ビロウとハイビスカス

市のデザインマンホールの中央には市章が、

市章のこぼれ話

沖縄市の頭文字の「お」を三つの円を主体として図案化したもので、三つの円をがっちり組み合わせ、市民の「調和・希望・平和」を象徴したもので、昭和四十九年九月二十日制定された。豊増秀男氏によってデザインされた。旧美里村の「ミサト」を丸く囲って旧村章と旧コザ市の「コ」を円形にして「ザ」をその円形の中に印した旧市章も示した。

沖縄市　ヤシ科のビロウとハイビスカスで外国ムード

なんと美しい花々なのじゃ

長崎にもある星のマンホール

その周りには市木のビロウと市花のハイビスカスが描かれている。

市に設置されているいくつかのマンホール蓋のうち、次頁に示した蓋の中央にコザ市の市章が入っており、その周りに星マークが配列されていて、米軍施政権下の時代を物語っているようでもある。調べてみると、このマンホールが設置されたのは昭和四十五年で沖縄の本土復帰前である。復帰後に沖縄市が誕生した昭和四十九年以後のものには星マークがなくなり、コザ市の市章の代わりに沖縄市の市章が入っている。

また不思議なことに、市章が異なるだけで、全く同じ星マークが配列されたマンホール蓋が長崎市にあり、長崎市のものは昭和四十年代前半

59

沖縄市 コザのマンホールはどことなくアメリカ風

> 復帰前に作られたマンホールのようじゃ

くらいまでに設置されたようで、設置時期もほぼ似ている。

両市ともに米軍基地があり、基地との関係もありそうだが、同一メーカーによるメーカー模様である可能性が高い。地域独自のオリジナルデザインマンホールには、その後昭和五十二年に那覇市で発祥したと考えられている。コザ市時代のマンホールが独り歩きして迷い子になり、那覇市までやってきたのを見つけた時には、探す楽しみを味わったり、脚の疲れを癒されたりした。その他に模様の異なる蓋が七つほどある。

60

沖縄市 エイサーをPRするキャラクターが登場

エイサーのまち

沖縄市は「エイサーのまち」を平成十九年六月十三日に宣言し、エイサーキャラクターのエイ坊が誕生した。このエイ坊は血液型がO型、好きな食べ物は旧盆カレー。このデザインマンホール蓋は「エイサーのまち沖縄市」をアピールするために、またエイサーを活かした観光振興の一環として製作され、市道に九十一個が設置されたという。沖縄市では、エイサー文化の継承と発展を目指して、毎年「沖縄全島エイサーまつり」が行われている。

北谷町 Chatan Town

Data

町　木：センダン
町　花：フイリソシンカ
　　　　（昭和57年4月1日制定）

北谷町について

北谷村北部の嘉手納などが昭和二十三年十二月四日嘉手納村として分村し、昭和五十五年四月一日町制施行で北谷町となる。

北谷町は「自立、交流、共生、住民と共に創造する「ニライの都市」北谷町」をキャッチフレーズにしている。この「ニライの都市」を人と自然が調和した創造性豊かな活力ある民主的な社会として定義し、まちづくりの目標としている。

CCZの文字

北前から美浜までの約三・五キロメートルに及ぶC・C・Z整備区域（コースタル・コミュニティー・ゾーン）のシンボルマークと町花のフイリソシンカが、上側には町章が、右側にはヤシの

町章のこぼれ話

「北」と「谷」を組み合わせ、大地を飛び立つ飛鳥のイメージに図案化して北谷町を象徴する。円は町民の融和を、飛鳥は町の発展を意味する。昭和四十八年四月二日に制定された。この町章は北谷村時代の二代目の村章で、町制後も継承されたものである。

北谷町 南国感がいっぱい

生えた浜辺が描かれている。コースタルコミュニティゾーンとは、海の彼方の理想郷を求める北谷町民の理念に基づき、北谷町西海岸及び護岸並びに当該道路周辺をいう。ゾーンの快適で和やかな環境を保全するため、平成四年三月三十一日利用に関する条例が定められている。

その他に模様の異なる蓋が七つほどもある。町章以外に「北谷」と印されたものもあり、これは初代の村章である。

初代村章

うるま市 Uruma City

Data

- 市　木：リュウキュウコクタン
- 市　花：サンダンカ
- 市花木：ユウナ
- 市　蝶：オオゴマダラ
- 市　鳥：チャーン
- 市　魚：マクブ
- 市　貝：トウカムリ（平成18年12月18日に制定）

うるま市について

うるま市は具志川市、石川市、勝連町、与那城町が平成十七年四月一日に合併して誕生した。「うるま」は珊瑚の島という意味で沖縄の美称である。「人と歴史が奏でる自然豊かなやすらぎと健康のまち」がキャッチフレーズ。

旧勝連町

旧勝連町の南風原には勝連城跡があり、平成十二年十二月二日に「琉球王国のグスク及び関連遺産群」の一つとして世界遺産に登録された。勝連平敷屋、与那城屋慶名、具志川赤野のエイサーは県下でも有名である。屋慶名エイサー、平敷屋エイサーは「日本の音風景百選」にも認定されている。うるま市は県内でも特に闘牛が盛ん

市章のこぼれ話

うるま市の「う」の文字を図案化したもので、赤は太陽、緑は大地、青は海をイメージしている。豊かな自然の輪の中で市民の融和と平和を表現し、金武湾と中城湾に面して発展する「うるま市」の明るい未来と更なる飛躍を象徴する。平成十八年三月一日制定された。

旧勝連 ニンジンの背景には津堅島

津堅島はやっぱりニンジン

な地域で古くから大衆娯楽として親しまれてきた。闘牛が安慶名闘牛場や石川多目的ドームなどで行われる。また宇堅ビーチ、伊計ビーチ、大泊ビーチなどでは夏場に海水浴やマリンスポーツが行われ、賑わっている。

旧勝連町津堅島のデザインマンホールの蓋は中央に津堅島が描かれ、その上側に旧勝連町の町章が、島を挟んで島の特産品であるニンジンが手をつないでおり、その下側に海が描かれている。島の特産品がユーモラスにデザインされている。

伝統の平敷屋エイサーも

旧勝連町の町章は「かつ」を飛鳥と波を想像し、

旧勝連 整然と踊る平敷屋エイサー

旧勝連といえば平敷屋エイサー躍動感があるのう

旧石川市

平和と希望を溢れることを目的として意匠化したものといい、昭和五十三年八月十四日制定されている。津堅島を除く旧勝連町の蓋には平敷屋の伝統芸能であるエイサーが見事に描かれ、「かつれん」と書かれている。うるま市になってからは「うるま市かつれん」と書かれている。

旧石川市のマンホールの蓋は中央に石川の伝統文化である闘牛が、上側に旧石川市の市章と伊波メンサー織の紋様が、下側に旧市の花木であったサンダンカとリュウキュウコクタンが描かれている。うるま市になってからは蓋の中央にうるま市市章が、その下側に闘牛、両側にエイサー、上側にウインドサーフィンの図柄があり、縁に沿ってオオゴマダラが描かれている。

66

旧石川市の市章は上部に「石」・下部に「川」を円く図案化しかつ飛鳥の形に意匠化し、融和と発展を目的として組み合わせて図案化したものといい、昭和四十四年六月十日制定されている。

市章のこぼれ話

旧石川 は今でも闘牛場が大にぎわい

旧石川 復帰前は軍人向けのビーチリゾート地であった

旧具志川 電照菊で知られ、マンホール中央にもキクの花

旧具志川市

伊波メンサー織は木や竹の棒で作られた原始的な織り具を用いて織られるという。昭和五十八年旧石川市民俗文化財に指定されている。伊波貞子さんが、平成十年に伊波メンサー織の技能保持者に、平成十九年に沖縄県工芸士に認定され、平成二十一年に伝統文化ポーラ賞を受賞している。

旧具志川市は闘牛が盛んな所で闘牛組合主催で石川多目的ドームで具志川闘牛大会が行われる。旧具志川市のデザインマンホール蓋の中央には旧市花であったキクの花が、その花の中に旧市章が描かれている。その周囲に闘牛の場景が大きく描かれている。うるま市以後のものは旧具志川市市章の代りに「うるま市」と書かれている。

旧与那城 クヮーディーサーは与那城のシンボル

旧与那城町

旧与那城町のデザインマンホール蓋はその後のものでは旧与那城町の町木であったクヮーディーサー(モモタマナ)をモチーフに、その枝分かれ部分のある中央に旧町章が描かれている。うるま市以後のものでは「クヮーディーサー」の文字の代わりに「うるま市よなしろ」になっている。

それ以前には中央に旧与那城町の町章が描かれ、その周りには波頭の連続模様が配列されたものがあった。

嘉手納町 Kadena Town

Data

町　花：ハイビスカス
町　木：クロキ（リュウキュウコクタン）
　　　（昭和57年8月5日制定）

嘉手納町について

北谷村から、昭和二十三年十二月四日に、嘉手納村として分村し、昭和五十一年一月一日町制施行で中頭郡では初の町となる。町の面積は十五・〇四平方キロメートルでその約八十三％が嘉手納基地として接収されている。

まちの将来像「ひと、みらい輝く交流のまちかでな」をキャッチフレーズにして実現に向けたまちづくりを進めている。

カデナロータリーをイメージ

デザインマンホールの蓋はロータリーを象って三等分され、中央に町章、蓋の三分の二に町花ハイビスカス、三分の一に「野国いも」が描かれていて、カラーバージョンもある。もう一つの

町章のこぼれ話

「かでな」の頭文字を飛鳥のイメージに図案化し、町民の親和と団結を表すと共に町勢の向上発展を単純明快に象徴化したものである。昭和四十八年五月十七日制定された。町章が制定される以前のものでは「カデナ」が図案化されていた。

嘉手納町 三等分され、町のシンボル「野国いも」が描かれている

嘉手納町 同じデザインのカラーバージョンも

蓋はJIS規格模様の図柄で、その中央のマークは「カデナ」を表現したもので、町章制定以前のものである。その他に模様の異なる七つほどの蓋がある。

「野国いも」のふるさと

慶長十（一六〇五）年野国総官が中国福建省より甘藷を持ち帰ってから四〇〇年の節目を迎える平成十七年にはその偉業を奉祝する「野国総官甘藷伝来四〇〇年祭」が町民により行われ、これを機に甘藷発祥の地「嘉手納」を全国に発信するとともに、野国総官を称え、甘藷を「野国いも」の愛称で呼ぶことを九月三十日に宣言している。野国総官の墓は昭和三十一年二月二十二日に「県指定の史跡」となっている。町は生活環境の整備と比謝川の汚濁防止を目的に、復帰前の琉球政府の認可で下水道事業に着手している。平成二十一年度末で人口普及率一〇〇％、水洗化率九六・九％になり、生活環境の改善に成果を上げ、比謝川の水質改善にも大きく貢献している。

Column 4

マンホール博覧会

パビリオン❷ー「一般的なマンホール」

デザインマンホール以外にもJIS規格などの一般的なマンホールが各地にはある。ここではその一部を紹介したい。

読谷村 Yomitan village

Data

- 村木　　フクギ
- 村花　　ブーゲンビレア
- 村花木　イペー

（昭和61年4月5日制定）

読谷村について

もともとは読谷山（ユンタンザ）村であったが、昭和二十一年十二月十六日改称した。読谷村の地形形象は残波岬を頭として東シナ海に飛び立とうとする鳥の形に似ていることから、村の将来像を「飛鳳花蔓黄金環」と表現している。村づくりの目標として「ゆたさある　優る肝心　咲き誇るや」をキャッチフレーズにしてあるべき姿としている。

読谷山（読谷）宇座出身の「泰期」は、中山王察度の命により、明（中国）への使者としての最初の遣明使であった。その後四回にわたって明に行っている。「おもろさうし」第十五の六六に「宇座の泰期思いや　唐商い　流行らちへ　按司に思われれ…」から進貢貿易船を出して交易を行う大貿易家であったと推察されている。

村章のこぼれ話

よみたんの「よ」と「み」をつないで村民の協力を表し、羽形は村の飛躍を表す。外円は村民の融和と団結の力を、囲まれた空間は豊かさと発展を象徴する。

読谷村 花織の図柄の中に、読谷山出身の泰期が乗ったとされる進貢船が描かれている

> このマンホールには読谷の村章があるが、見つけたのは那覇じゃ どうやってやってきたのか…

進貢船と花織

村には伝統工芸品の読谷山花織（ユンタンザハナウイ）があり、国指定重要無形文化財（平成十一年六月二十一日指定）、県指定無形文化財（昭和五十年四月十日指定）でもある。

蓋の中央には「進貢船」が、その周囲に「読谷山花織」が、上側には村章が描かれている。読谷山花織は十四・十五世紀頃の南蛮貿易で伝えられたといい、代々継承されてきた文化遺産であるという。

Column 5

マンホール博覧会
パビリオン❸ －「綱引き」

糸満市①

糸満市②

旧玉城村

与那原町

宜野座村

76

北部

A Picture Book of Okinawan Manhole Cover Design

恩納村 Onna village

Data

村　木： フクギ
村　花： ユウナ（オオハマボウ）
（祖国復帰一周年を記念して
昭和48年5月15日制定）

恩納村について

恩納村では陶芸、ガラス工芸などの伝統工芸も盛んに行われている。また多くのビーチがあり、環境省の「快水浴百選」に、万座ビーチ（海の部特選）、リザンシーパークビーチ（海の部特選）、ルネッサンスビーチ（海の部特選）、マンマリーナビーチ、ムーンビーチが選ばれている。

さらに沖縄島のほぼ中央に位置して最も目立ち琉歌にも謡われた「恩納岳」や景勝地で絶壁に象の鼻の形をした岩がある「万座毛」などはよく知られている。

村は昭和六十三年四月一日に恩納村民憲章を制定し、また「青と緑の躍動する村住んでよく、働いてよく、訪れてよい村」をキャッチフレーズにしている。村花のユウナは黄色の花で、和やかな香りは平和と純真を表す。フクギは大地に

78

恩納村 県下有数の名勝地

恩納岳と万座毛

恩納村のデザインマンホールの蓋には中央に恩納岳、上に村章、左上にユウナ、右下に海に浮かぶヨット、左下に万座毛が描かれている。県下有数の景勝地である万座毛は「県指定名勝」として昭和四十七年五月十五日指定されている。

どっしりと根を張り、平和と無限の繁栄を表す。

村章のこぼれ話

「オンナ」を水平に図案化し、円は平和を表して村民の一致団結を意味し、左右に鋭く延長して平和の中にも村の飛躍発展の姿を象徴したものである。（昭和四十八年五月十五日制定）

花と水の里

もう一つの蓋は恩納岳、そこから流れる水、水車、キクの花が描かれていて、「花と水の里」と書かれている。喜瀬武原はキク栽培が盛んな地域でその土地柄をよく表現している。

リュウキュウマツも

さらに、もう一つの蓋には上側に村章、恩納岳、空に浮かぶ雲、かつて街道にあったというリュウキュウマツ並木のイメージ、ユウナ、万座毛と海が描かれている。恩納岳にまつわる琉歌に「恩納岳あがた 里が生まり島 むいん押しぬきてぃ くがたなさな」(恩納岳の向こう側に愛する人の郷があり、このじゃまな恩納岳を押しのけて彼の郷をこちらに引き寄せよう)があり、歌人の恩納ナビの歌という。

恩納村 自然の豊かさが伝わる

Column 6

思い出深いマンホール

　デザインマンホールには、各地の名産・特産・名所が盛り込まれており、いわば各自治体の顔とも言える作品ばかりである。実に「路上のアート」、いずれをとっても遜色がないものばかりであるが、あえて思い出深いマンホールを挙げてみよう。

　琉歌が書かれている中城村のデザイン蓋、詩が書かれている伊是名村のデザイン蓋、座間味村慶留間島の瓦屋根のデザイン蓋、那覇市首里のかすり模様のデザイン蓋に、とりわけ強い印象を受けたものである。

　いずれも、わたしがかつて幼少期を過ごした時代の、のどかな農村風情であったり、大人が着ていたバサージンの伝統的なかすり模様を思い出すものばかりだ。マンホールを眺めていると、昔懐かしい思い出まで蘇ってくるのである。

金武町 Kin Town

Data

町　木： クバ
(昭和52年11月21日制定)

町　花： サクラ
(昭和53年1月6日制定)

金武町について

昭和二十一年四月一日に金武村から宜野座村の分村が認可されて、金武村は中川、並里、金武、伊芸、屋嘉の五行政区となる。昭和五十五年四月一日に町制が施行されて金武町と成り、現在は「心豊かな明るく住みよい活力あるまち」づくりをめざしている。キャッチフレーズは「海外雄飛の里　心豊かな明るい健康文化のまち」。

金武地区、並里地区の大地は広く琉球石灰岩が分布して地下水が豊富であり、水どころとして知られている。湧水が豊富なため田芋の栽培が盛んである。

屋嘉地区はカンカラ三線

屋嘉地区では稲作も行われており、屋嘉のデ

屋嘉区 収容所で生まれた「屋嘉節」を彷彿させる

町章のこぼれ話

金武町の頭文字「キン」を円と翼のイメージにデザイン化し、町民の融和、平和、団結を表すと共に、町勢の雄飛発展を表現し金武町の輝く将来を力強く象徴したものである。長沢知子氏のデザインである。昭和五十二年十一月七日制定された。

ザインマンホールは中央に町章、上側に稲穂、下側左にパイナップル、右にカンカラ三線が描かれている。戦後、屋嘉には米軍の捕虜収容所があり、そこで"カンカラ三味線(三線)にのせて"屋嘉節"が歌われ、歌う方も聞く方も涙を流したという。カンカラ三線は収容所の人たちが空き缶、木材、パラシュートのひもで自作したという。戦後の歴史を垣間見ることができる。

| **ターム(田芋)が特産の並里区** |

並里区

並里地区のものには特産品の田芋と旧暦八月十五日に行われる獅子舞の獅子と町花の桜の花が描かれている。獅子舞は明治二十八年に途絶えたが、昭和八年に

83

金武町 町花のサクラが用いられている

金武町のマンホールは中央に山すそに咲く桜の花、上側に空に浮かぶ雲の中に町章、下側に波と海に浮かぶヨットが描かれている。町の東側の海はマリンレジャーに好適地。

タコライスをマンホールでPR

「ようこそ田芋の郷へ」というカラーバージョンがある。それには金武町キャラクター「ターム君」が描かれている。さらに「巨大タコライスギネス認定二〇一〇年十一月十四日」とある。

タコライスは一九八〇年代に金武の「パーラー千里」で米軍人の大好きなタコスの具をご飯に乗せたのが始まりだという。創業者の儀保松三氏が米兵のために考案し、昭和五十九年に

復活させて、現在まで伝承し、百年以上の歴史があるという。

ここで「ギネス認定タコライス」をPRしている

金武町　ウチナー漫画家・ももココロ氏によるイラスト

　生まれたという。学生がタコライスを食べにわざわざ金武まで行ったことをよく話していたものである。
　「パーラー千里」は平成二十七年六月二十九日閉店したが、同じタコライスは系列店の「キングタコス」で提供しているという。
　金武のタコライスがギネス認定されたのはマンホールにある通り二〇一〇年十一月十四日。町内外から二一〇〇人が参加して、長さ十二メートル、幅一・八メートル、重さ七四六キロ、二千食分相当のタコライスを作り、その場で正式なギネス記録として認定された。

宜野座村 Ginoza village

Data

村　木：琉球松
村　花：ツツジ
村　鳥：メジロ
村　魚：ミーバイ（ハタ）
　　　（昭和57年7月29日制定）

宜野座村について

昭和二十一年、金武村北部の四つの字が分村して宜野座村が成立した。宜野座村は「水と緑と太陽の里・宜野座村」をキャッチフレーズにしている。平成二十二年三月には「有機の里宜野座村」を宣言し、「安心安全な農産物」づくりに取り組んでいる。宜野座村は伝統芸能が盛んに行われている地域で、六区から成る。福山区以外の各区のデザインマンホールには各区の個性豊かなデザインと村章が描かれている。

松田区は琉球松と獅子

松田区のマンホール蓋には松田区の守り神の獅子と琉球松および緑が、さらに背景には古知屋岳とダムの水が描かれている。獅子は「獅子ガ

村章のこぼれ話

「きのざ」の頭文字「ぎ」を図案化し、左に伸びる鋭角は村の発展を、円は村民の融和を表し、村章の色オレンジはみのりの豊かさを表している。(昭和五十一年十一月二十七日制定)

松田区 琉球松の前に獅子

旗頭や京太郎・宜野座区

ナシ」とも言われ、区の守り神として獅子舞の終了後も舞台に安置されるという。松田と宜野座の両区には十五夜アシビ(伝統的豊年祭)がある。

宜野座区のマンホール蓋の中央には旗頭、左側に県指定無形民俗文化財(昭和六十年十月八日指定)の「宜野座の京太郎」、右側に「獅子」、上側に琉球松の枝が描かれている。

宜野座の京太郎は明治中期に寒水川(すんがー)芝居出身者の渡久地武恭氏によって宜野座に伝えられ、明治三十三年八月十五日(旧暦)の豊年祭で舞台芸能として演じられたのが始まりという。代々継承してきた宜野座区二才団が保持団体となっている。

87

宜野座区は伝統芸能が満載じゃ

宜野座区 県指定文化財「宜野座の京太郎」

惣慶はガラマン岳が見えるぞ

惣慶区 たいまつを掲げる綱引きの様子

惣慶区は綱引きとガラマン岳

綱引きの綱と支度（シタク）、旗頭、エイサー、松の枝などが描かれている。背景の山はガラマン岳で、ガラマンは荷鞍を下ろした馬の背中に似ていて、空馬（からうま）が訛ってガラマンになったという説が有力であるが、他説もある。

漢那区はタラソ、城原区はメジロとツツジ

三等分され、漢那ダム、漢那ビーチ、かんなタラソが描かれている。漢那ダムは平成五年五月に通水式が行われ供給が開始された。毎年「漢那ダムまつり」が行われ、平成十七年三月十六日に「ダム湖百選」に認定されている。城原区の蓋も三等分され、それぞれに村木の琉球松、村鳥のメジロ、村花のツツジが描かれている。

城原区 自然豊かな図柄

漢那区 ダムも描かれている

名護市 Nago City

Data

シンボル： ガジュマル、カンヒザクラ、リュウキュウメジロ、テッポウユリ、スイジガイ、シロギス、コノハチョウ

（市制3周年を記念して、昭和48年8月1日に制定）

名護市について

名護市は、昭和四十五年八月一日、名護町、羽地村、久志村、屋部村、屋我地村の五町村が合併して誕生した。「あけみおのまち名護市」がキャッチフレーズ。「あけみお」は夜明けの美しい静かな入り江の青々とした水の流れの意。

かわいいメジロと花々

カンヒザクラ、テッポウユリの花とリュウキュウメジロが、中央には桜の花の中に市章が描かれている。昭和五十四年には名護下水処理場が完成した。平成十五年度には国土交通大臣賞（いきいき下水道賞）を水環境回復創出部門で「甦った幸地川（こうちがわ）ー市民が集うゆとりとうるおいの場の創成」の事例名で受賞している。

90

市章のこぼれ話

名護市の頭文字「ナ」を飛び立つ鳩に形どり名護市の永遠の平和とかぎりない飛躍を象徴している。あおみどりは自然の環境の中で豊かな人間性を養う市民の願いを表わしている。昭和四十七年八月八日制定。

名護市　「桜一番トロピカルフルーツの町」を
キャッチフレーズにさくらまつりも毎年開催される。

同じデザインで
カラーバージョンも
あるのじゃ

本部町 Motobu town

Data

- 町　木：フクギ
- 町　花：ラン
- 町花木：カンヒザクラ
- 町　鳥：リュウキュウコノハズク
- 町　魚：カツオ
- 町　蝶：コノハチョウ、フタオチョウ
 （昭和62年12月10日制定）

本部町について

本部町は本村村が昭和十五年十二月十日に町制が施行されて誕生した。昭和二十二年には町北部の九字が行政分離して上本部村となったが、本土復帰前年の昭和四十六年に両町村は再び合併して本部町となった。

町は「太陽と海と緑―観光文化の町」づくりをめざして町民憲章を定めている。瀬底大橋は昭和五十四年に着工し、昭和六十年二月十三日開通した。開通以前は上陸用舟艇が渡し船として往来していた。

元気なカツオとコノハチョウ

町のデザインマンホールの蓋は中央に町章と瀬底大橋が、その上側に海を泳ぐカツオが、下側

町章のこぼれ話

本部町の頭文字「本」を図案化したもので、"日本"を強調させ、円は平和と円満を表し、左右両翼の羽根型は町の飛躍発展の姿を象徴している。昭和四十一年十二月十五日制定された。

本部町 本部大橋をバックに

にサクラ、リュウキュウメジロ、コノハチョウが描かれている。

本部町は沖縄本島唯一のカツオ漁の町として発展してきた。カツオの初水揚げにあわせて、渡久地港の大空に"カツオのぼり"の泳ぐ姿がみられる。八重岳のサクラは全国一早く咲くことで有名である。コノハチョウは沖縄県の天然記念物に指定されており、木の葉に似た擬態をすることでよく知られているチョウである。

その他に模様の異なる蓋が四つあり、沖縄海洋博のマークの波頭が描かれているものもある。

93

東村 Higashi village

Data

- 村 花： ツツジ
 （昭和38年に選定され、昭和53年4月1日に指定）
- 村 鳥： ノグチゲラ
- 村 木： ヒルギ
 （ともに平成5年4月1日に指定）

東村について

東村は大正十二年四月一日に旧久志村（名護に合併）から分離独立して誕生した。旧久志村の東方に位置し、東の空から赤々と朝日が昇り、「日の出るところ東なり」から命名されたという。「花と水とパインの村」をキャッチフレーズにしていて、「山と水の生活博物館」が平成十六年二月一日にオープンしている。

慶佐次川河口域にはオヒルギ、メヒルギ、ヤエヤマヒルギから成るヒルギ林が発達して、昭和四十七年五月十五日国指定天然記念物に指定されている。このヒルギ林を資源として利活用したカヌー漕ぎによる観光が行われている。河口の汽水域を保全するために下水道が設置されている。

村章のこぼれ話

光は東方水平線上より昇る太陽を表し、その影は末広がりになっていて、東村の限りなき発展を象徴している。村章の色は太陽が金色で、村の豊作すなわちみのりを表し、地色は濃紺で、村民の叡智を表しているという。昭和三十八年十二月に選定され、昭和五十三年四月一日に制定されている。

東村 観光客にも人気のカヌーが描かれている

ヒルギ林をゆくカヌー

デザインマンホール蓋には、水域に浮かぶカヌーとヒルギ林、および村章が描かれている。東村では水産資源であるノコギリガザミを育てるために慶佐次川に放流を行っている。

天然記念物であるマングローブのすぐ間近まで行けるエコツアーは、自然を満喫できる人気の観光体験である。

大宜味村 Ogimi village

Data

村　木：シークヮーサー
村　花：シークヮーサー
村　鳥：メジロ
（昭和56年8月1日制定）

大宜味村について

大宜味村は幾多の字の合併分離をくり返して、現在では十七字をもって構成されている。「健康長寿のいきいき輝く文化の村」をキャッチフレーズにしている。

シークヮーサーの里宣言が平成十七年十月一日に行われている。「大宜味村の花」「大宜味村の木」に制定されているシークヮーサーを村民一人一人の誇りとして大切にしつつ本村の特産として振興し、元気で魅力あるシークヮーサーの里づくりを推進することを目的としている。

また、ぶながやの里宣言が平成十年七月二十四日に行われている。宣言の中の一部に、以下のようなことが書かれている。

大宜味村の森や川には、今ではここにしか生息しなくなった「ぶながや」が棲んでいる。「ぶな

村章のこぼれ話

「大」の文字を近代感覚により図案化したもので、村民の融和団結を円でもって表し、さらに輝く大宜味村の将来発展を左に伸びる翼形で表現し、輝く大宜味村の将来を端的に力強く象徴したものである。昭和四十七年一月一日を制定される。

大宜味村 全国公募によって決まったぶながやのキャラクター

がやは、平和と自然を愛し、森や川の恵みを巧みに利用し、時折私たちにその姿を見せてくれる不思議な生き物である。私たち村民は、「ぶながや」たちと生きてきたことに誇りを持ち、これからもこの大宜味村の豊かな自然のなかで共生し、平和で文化の薫り高い豊かなむらづくりに取り組むことを決意し、ここに「ぶながやの里」を宣言する、とある。

やっぱりシークヮーサーとぶながや

デザインマンホールの蓋には「シークヮーサーぶながやの里」と書かれていて、ぶながやキャラクターをモチーフに、シークヮーサーの実とその断面と葉が描かれている。そのキャラクターは全国公募し、村民が想像するものに近い作品が選定されたという。

「ぶながや」は「からだ全体が赤くて、子供のように小さい」、「赤い髪をたらしている」、「赤い火を出したり、火のように飛んだりする」、「山や川や木の上でみかける」、「漁が上手で、魚やカニを食べる(魚は目玉だけ)」、「すもうをとるのが好きである」、「木(薪)を持たない」、「人の加勢はするが、里には入らない」、「人なつっこく、自ら人に害を加えることはしない」、「祈願によって追い払うことができる」という特徴を持っているという。

結の浜公園が平成二十六年にオープンし、PRキャラクターの「おおぎみシーちゃん」と「ぶながや」が訪れる人を歓迎している。大宜味村はまた「芭蕉布の里」でもある。

結の浜公園にはおおぎみシーちゃんとぶながやがいるよ。

離島

A Picture Book of Okinawan
Manhole Cover Design

伊平屋村 Iheya Village

Data

村　木：クバ
村　花：ツツジ（タイワンヤマツツジ）
村　魚：イシミーバイ
　　　（平成元年8月7日制定）

伊平屋村について

伊平屋島は「てるしの」、すなわち太陽神の島、とも言われる。明治四十二年四月一日村制施行で伊平屋は伊是名を含めて伊平屋村と改称され、村役場は伊是名に置かれた。そのため行政運営や島民にとって不便をきたして分村問題が持ち上がり、ついに昭和十四年七月一日に、内務省令による分村許可で、伊平屋村が誕生した。『てるしの』の島　うるおいと活気あふれるたのしい村』をキャッチフレーズにしている。

念頭平松の美しさ

島のデザインマンホールは下半分に樹齢二百六十年以上と言われる念頭平松が、上側には模様と村章が描かれ、縁に沿って「きれいな水で住

村章のこぼれ話

伊平屋の「イヘ」の文字を飛鳥のイメージに図案化し、村の融和・平和・団結を表すとともに、産業文化の雄飛発展を力強く象徴している。(昭和五十二年四月一日制定されたが、同五十八年四月一日再制定された)

伊平屋村 樹齢260年ともいわれる念頭平松

みよい村に」と書かれている。念頭平松は昭和三十三年一月十七日に県の天然記念物に指定され、平成二年には新日本名木百選にも選ばれている。この美しい松を称える琉歌に「念頭平松の枝振りの清らさ　田名のみやらびの身持清らさ」がある。また、この平松は久米島の「五枝の松」とともに二大名松として知られている。稲作が盛んで、県内で二番目の生産高を上げている。戦前の昭和十六年には全国米作共進会で、沖縄県から米作増産の一等賞に表彰され、自給自足が可能な村として賞賛された。デザインマンホール以外に五つの模様の異なる蓋が知られているが、三つは確認することができなかった。

伊是名村 Izena Village

Data

村　木：ウバメガシ
村　花：サンクバーナ(トウサツキ)
　　　　(平成元年3月22日制定)

伊是名村について

伊是名村は昭和十四年七月一日に伊平屋村から分村し、単独村政を施行して誕生した。伊是名村は「ときわの島いぜな」とも呼ばれている。「健康で明るい住み良い環境、豊かな村づくり　ときわの島　いぜな」を標語にしている。

尖った岩山・ギタラがモチーフ

陸ギタラと海ギタラが描かれている。ギタラは尖った岩山の意味であるという。すなわち、伊是名山の一部であるアハラ御嶽のウバメガシ及びリュウキュウマツ等の植物群落が、その背後に海と雲が浮かぶ空と村章が描かれ、さらに「えにしあらば　又もきてみん　伊是名島　田の面に続く　松の村立ち」と書かれている。アカラ御嶽の

村章のこぼれ話

「イゼナ」を図案化したもので、円は村民の親和を象徴している。限りない発展を続けるようにとの意味がこめられている。昭和四十四年八月十五日制定された。

伊是名村 沖永良部からの役人が詠んだとされる詩も

ウバメガシ及びリュウキュウマツ等の植物群落は県指定の天然記念物で、昭和五十二年五月九日に指定されている。アハラ御嶽は地元ではアハラ御嶽と言っている。伊是名山は村の自然環境保全地域に指定され、自然環境の適正な保全が図られている。「えにしあらば…」の詩は沖永良部島の与人（地方役人）が詠んだものと伝えられている。「松の村立ち」とあるが、それは「松の群立ち」であろう。このように王国時代から賞賛された美しい島である。伊是名島は戦後の昭和三十五年頃までは昔ながらの田園風景が広がり、水稲は換金作物の首位を占めていたが、その後はサトウキビにその首位を奪われていったという。

座間味村 Zamami Village

Data

村　花：ケラマツツジ
村　木：リュウキュウマツ
（平成6年3月1日制定）

座間味村について

「碧い海と珊瑚礁の島々　自然にやさしく、自然を活かす島づくり　アクティブ・エコロジー・アイランド」をキャッチフレーズにしている。

座間味島近海では毎年十二月から四月頃までザトウクジラが見られ、一月中旬から三月中旬までがウォッチングシーズンのピークである。ザトウクジラはヒゲクジラ類に属し、歯を持たずにくじらひげで餌をとる。冬になると低緯度地方の暖かい海域に回遊し、交尾や子育てを行うという。

座間味村でケラマジカが現在生息している島は屋嘉比島、慶留間島、阿嘉島であり、前二島は地域指定を受けている。

かつて阿嘉島に生息していたシカは農作物を荒らすため捕り尽されたといわれており、現在

座間味島 周囲には熱帯魚が

座間味はクジラのフルークアップ

座間味島のデザインマンホールの中央部には村章とクジラが尾びれを高々と水面上に上げている状態（フルークアップ）が、蓋の縁の周りには熱帯魚とサンゴが描かれている。

この島にいるシカは隣の慶留間島あるいは屋嘉比島から海を渡ってきたと考えられている。昭和四十七年五月十五日国の天然記念物に指定された。シカが海を渡ることを村の人たちは「島渡り」と呼んでいるという。

村章のこぼれ話

座間味のザを図案化したもので、紺と黄は島の豊かさ、円にまとまった区画と中央の横画は島の平和と限りない発展を象徴したものである。昭和四十一年五月一日制定された。

105

阿嘉島 近隣の島から海を渡ってくることでも有名なケラマジカ

ケラマジカとツツジ

阿嘉島のデザインマンホールにはケラマジカをモチーフに村章と村花のケラマツツジが描かれている。

ケラマジカは阿嘉島、慶留間島、屋嘉比島で生息するが、屋嘉比島と慶留間島のケラマジカのみが「国の天然記念物」として地域指定されており、屋嘉比島は立入禁止区域である。琉球国由来記巻四によると、その鹿は、崇禎年間（一六二八〜一六四四年）に、尚氏金武王子朝貞が、薩州（薩摩、鹿児島県）より持ち帰り、慶良間諸島のうち、古場島（久場島）に放飼し

「天然記念物ケラマジカ及びその生息地」の標識

慶良間島 一対のシカと赤瓦屋根の民家

たという。写真の「天然記念物 ケラマジカ及びその生息地」の標識が立っている道路反対側の保護区域でケラマジカを運よく見ることができた。偶然とはいえ阿嘉大橋を渡ってきてく歩いてきた疲れをやさしく癒してくれた喜びを味わったものである。

なつかしい慶留間の集落も

慶留間島のデザインマンホールには昔ながらの石垣に囲まれた赤瓦屋根の「高良家」が描かれ、シカと村章が印されている。高良家は国指定重要文化財。

渡名喜村 Tonaki Village

Data

村　木： フクギ（福木）
村　花： カワラナデシコ
　　　　（平成4年7月1日指定）

渡名喜村について

「温もりの海郷　渡名喜」をキャッチフレーズにしている。村木のフクギは屋敷林として植栽され、村花のカワラナデシコは渡名喜島と久米島に自生し、絶滅危惧（特）A類として保護されている。島の南部地域は古生代石灰岩で構成され、島の最高標高は大岳の一七九メートルで、山地は良質のドロマイト（マグネシウムやカルシウムの炭酸塩から成る岩石）を含有する。平成九年には、ほぼ島全域と周辺海域を含めて渡名喜県立自然公園に指定される。渡名喜村は平成十二年五月二十五日に「重要伝統的建造物群保存地区」の「島の農村集落」として選定される。

108

村章のこぼれ話

カタカナの「トナキ」を図案化したもの。「ト」「ナ」で円を構成し、村民が円満で協力一致の団結を表しています。「キ」は喜びであり、常に喜びを中心にキの横二本を延ばし渡名喜の限りない繁栄を希求する為の表現とした。昭和四十六年十二月十八日制定される。平和と発展をショウチョウするため円の中外に

渡名喜村　村花のカワラナデシコも見える

特産のモチキビと大岳

デザインマンホールの蓋はそびえ立つ大岳とモチキビ並びにカワラナデシコがデザインされ、中央には村章が印されている。平成七年度に汚水処理施設が完成し、生活環境が大幅に改善されたという。モチキビは渡名喜島の特産品として有名である。「もちきびちんすこう」は平成十九年の離島フェアで優良特産品として特別賞を受賞している。

デザインマンホール以外に波頭模様の一般的な蓋がある。

マンホールのデザインに使われた大岳とモチキビ

粟国村 Aguni Village

Data

- 村　木： フクギ
- 村　花： テッポウユリ
- 村花木： ソテツ（平成11年6月14日選定）

粟国村について

かつて農産物の中心が粟であったために、アワグニがアグニに転訛したという。「自然・ひと・暮らし ふくらしゃる粟国 てるくふぁ島」をキャッチフレーズにしている。「てるくふぁ」は島に照りそそぎ、島に恵みをもたらす太陽神のことという。村木のフクギは屋敷林として植栽され、フクギ並木は緑の村づくりを象徴している。村花テッポウユリの内外三枚の純白な花びらは村民の純粋な心と堅い団結心を表現し、その芳香は村の限りない発展を象徴している。

戦前・戦後の食糧難の時、ソテツの葉は燃料、実や芯は食材、雄花は肥料として、飢餓から救ったソテツは「生きる力」を象徴している。昔から水の乏しい粟国島では、西海岸にある凝灰岩をくりぬいた大きな水がめ（トゥージ）に雨水を溜

粟国村 食糧難を救ったソテツは今も大切な存在

海を象徴する青地の中に粟国を象徴する頭文字「ア」を島の形態に合わせてデザインしている。その図は、粟国の3カ字に因んで三つの部分によって構成され、下辺の四辺形は村民の固い団結を表し、上方に広がる円弧は村の限りない発展を象徴している。昭和五十六年十一月三日に制定された。

村章のこぼれ話

ソテツで表す "生きる力"

ソテツをモチーフにデザインされ、さらに空に浮かぶ雲と村章が描かれている。ソテツは多量のデンプンを含み、救荒植物の一つであるが、サイカシンという毒がある。食糧難の時にはその毒を除去して食料にしていたが、処理が不十分のために死ぬこともあったという。そのために「ソテツ地獄」という言葉も生まれた。それゆえ飢餓の一時期も処理をして食べていた。戦後の飢餓から救ったソテツは「生きる力」を象徴しているという。

め飲料水にしていたという。

久米島町 Kumejima Town

Data

町　　花： クメジマツツジ
町 花 木： 久米紅椿(くれないつばき)
町　　木： リュウキュウマツ、フクギ
町の動物： クメジマボタル
　　　　　（平成14年4月1日制定）

久米島町について

久米島町は平成十四年四月一日に旧具志川村と旧仲里村が合併して誕生した。

久米島は古来、「球美(くみ)」そして、「久米島(くみじま)」と呼ばれてきた。「ラムサール条約登録の地　活力・潤い・文化を創造する元気なまちー久米島ー」をキャッチフレーズにしている。

久米島の渓流・湿地がラムサール条約湿地に平成二十年十月三十日に登録された。クメジマボタルは平成五年に発見された新種のホタルで、清流域にのみ生息する。国内ではゲンジボタルとヘイケボタルに次いで幼虫が水生生活する三番目のホタルである。幼虫はカワニナ類を餌として成長する。平成六年二月四日県の天然記念物に指定され、また絶滅危惧Ⅱ類（VU）にも

112

町章のこぼれ話

古称「球美（くみ）」そして、「久米島（くみじま）」より、「く」を三つ並列して「く」「み」をあらわし、全体を躍動する形態にすることで久米島町のさらなる発展を象徴する。外輪（楕円）は久米島町民の「和」を象徴する。デザイン色について、黄緑は美しい島の緑と豊かさを象徴する。青は澄みきった海と空をあらわし、深い友情と限りない交流を象徴する。平成十六年五月二十五日制定される。

久米島町 ホタルの光の意匠がかわいい

指定されている。平成二十四年には環境省第四次レッドリストで絶滅危惧Ⅱ類から絶滅手前となる絶滅危惧ⅠA類に指定される。

クメジマボタルの旧具志川村

旧具志川村のデザインマンホールの蓋には五枝の松とクメジマボタルが描かれ、さらに旧具志川村の村章が印されている。

旧村章は「グシ川」を図案化したもので、昭和五十七年一月に制定されている。

久米の五枝の松は「県の天然記念物」として昭和三十四年十二月十六日指定される。

旧仲里村は久米島紬

旧仲里村のデザインマンホールの蓋は久米島紬の図柄をモチーフにデザインされ、中央には旧仲里村の村章が描かれている。旧村章は「ナ」と久米島紬反を重ね合わせたもので、昭和五十六年一月一日に制定されている。久米島紬は、昭和五十年に、伝統工芸品として当時の通産産大臣の指定を受け、五十二年には県の無形文化財に、平成十六年には国の重要文化財に指定される。

ここに挙げたデザインマンホール以外に八つほどの模様の異なる蓋がある。

ある民宿のオーナーが費用をかけてタイル張りで五枝の松の大きなアピール板を完成させている。そのデザインにはクメジマボタルが光っている様子と「久米の五枝松や　下枝どまくら　うみわらび無蔵や　吾腕まくら」と書かれている。

面白いことに、海を渡ってコザ市時代のマンホール蓋や浦添のマンホール蓋及び止水栓を見つけた時には、発見の喜びが脚の疲れを癒してくれて気分爽快になったものである。また希少な蓋を探すために十五キロも自転車で巡って見つけた時のうれしさは何とも言えなかった。

レンタカーが借りられずに自転車を貸してくれた民宿のオーナーに感謝したい。

タイル張りのアピール板

仲里村 紬の柄が放射状に配置されている

久米島町になってからのバージョンじゃ

久米島町
その他のマンホールの一部

宮古島市 Miyakojima City

Data

市　木： ガジュマル
市　花： ブーゲンビレア
市花木： デイゴ
市　鳥： サシバ　　市　魚： タカサゴ
市　蝶： オオゴマダラ　市　貝： スイジガイ
（平成18年4月5日制定）

宮古島市について

宮古島市は平成十七年十月一日平良市、城辺町、伊良部町、上野村、下地町の五市町村が合併して誕生した。宮古島市は宮古島、伊良部島、下地島、池間島、来間島、大神島から成る。「こころつなぐ 結いの島 宮古」をキャッチフレーズにしている。

パーントゥもやってきた

旧平良市のデザインマンホールの中央には旧平良市の市章が、その周りにTRIATHLONと書かれているように、上側に三キロメートルを泳ぐ水泳、一三六キロメートルを漕ぐ自転車、四二・一九五キロメートルを走るマラソンの三つの図柄が、中央の左右両側

市章のこぼれ話

宮古島市の頭文字であるひらがなの「み」をモチーフに、宮古島市民が未来へ飛躍する様子を美しい海や空、緑の大地、太陽をイメージしたデザインである。平成十七年十月一日制定される。

旧平良 このデザインは中央の市章を替えて宮古島市に引き継がれた

小型蓋

には島尻のパーントゥが、下側にはクイチャーを踊る姿が描かれている。各図柄のほかは全体的にサシバの飛翔図が描かれ、宮古島を代表するイベントをうまく表現している。

クイチャーの語源は諸説あるが、クイ（声）を合わせる（チャー）が有力であり、人々が円陣を組んで唄い踊りながら手足を振り声を合わせる踊りである。パーントゥは仮面を被った来訪神であるという。宮古のパーントゥは「国の無形民俗文化財」に昭和五十七年十二月二十一日選定される。宮古島トライアスロンは昭和六十年に始まりバイクが一三六キロであったが、平成三年から一五五キロとなり、平成二十七年には一五七キロになっている。小型蓋にはパーントゥは描かれていない。

城辺の名勝・東平安名埼

旧城辺町のデザインマンホールの蓋は東平安名埼をモチーフに灯台と旧町花であったテッポウユリをあしらい、中央には旧町章が印されている。

この灯台は大型で「日本の灯台五十選」に選ばれ、その周辺は「日本の都市公園一〇〇選」に選定されている。高さが二十四・五メートルもあり、昭和四十二年三月二十七日初点灯し、東平安名埼灯台と称されたが、昭和四十七年五月十五日の本土復帰に伴い、平安名埼灯台に改称され、管理業務も琉球政府から海上保安庁に引き継がれた。

旧城辺 灯台と海がダイナミック

下地はサニツ浜カーニバル

旧下地町のデザインマンホールの蓋は中央部に与那覇湾で行われるサニツ浜カーニバルでの競馬の情景と旧町章が描かれており、蓋の縁に沿って旧町花であったハイビスカスの花が配列されている。

宮古島市誕生後のマンホールは旧平良市のデザインをそのまま活かして、旧平良市章の代わりに宮古島市の市章が印されている。

旧下地 旧3月3日の行事サニツでは古くから競馬が行われていた

石垣市 Ishigaki City

Data

- 市 木：ヤエヤマコクタン
- 市 花：サキシマツツジ
- 市 蝶：オオゴマダラ
- 市 魚：ハマフエフキ（タマン）
- 市 鳥：カンムリワシ
- 市 貝：クロチョウガイ

（昭和52年10月22日制定）

石垣市について

近世の八重山の村々は寛永五（一六二八）年に石垣、大浜、宮良の三間切に編成される。明治四十一年四月一日石垣、大浜、宮良の三間切と与那国島とを合せて八重山村となる。大正三年四月一日八重山村のうちの石垣島西部が石垣村に、東部が大浜村に分村する。昭和元年十二月一日石垣村が町制施行で石垣町となり、二十二年七月十日市制施行で石垣市となる。同年九月一日大浜村が町制施行で大浜町となる。昭和三十九年六月一日大浜町が石垣市に編入合併され、現在の石垣市となり、石垣島全体が市域となる。

「おーりとーり石垣市 日本最南端の自然文化都市」をキャッチフレーズにしている。

120

> **市章のこぼれ話**
>
> 石垣市の「石」の字を図案化したもので、石垣市の平和と限り無い躍進を象徴している。昭和四十二年四月八日制定される。

石垣市 名蔵湾から突如現れたと伝えられる赤馬

宮良川を駆ける赤馬

デザインマンホールは宮良川に架かる宮良橋を駆ける赤馬と愛称される駿馬の勇姿が、さらに市の蝶のオオゴマダラと宮良川のヒルギ及び市章が描かれている。宮良川のメヒルギ、オヒルギ、ヤエヤマヒルギから成るマングローブ林は昭和四十七年五月十五日国指定天然記念物に指定される。赤馬は宮良の赤馬伝説に出てくる名馬で、民謡に赤馬節がある。平成二十一年六月には赤馬の碑と像が建立されている。

市のシンボル・カンムリワシ

または市の鳥であるカンムリワシが木に止まっている姿と飛んでいる姿が、さらに市章と市の木のヤエヤマコクタンと思われる木の葉が

石垣市 石垣出身のボクサー・具志堅用高は「カンムリワシ」と称された

かっこいい
デザインじゃ

石垣市 1月から3月ごろ赤色の花を咲かせるサキシマツツジ

描かれている。カンムリワシは特別天然記念物に昭和五十二年三月十五日指定される。

もう一つは市の花であるサキシマツツジをモチーフにデザインされている。アカショウビンをモチーフにデザインされ、左上には市章が印されているものもある。

汚水を浄化して「海をきれいに」という意図が込められているように思われる。

白保の海を美しさを表現

白保のデザイン蓋には三本の木が描かれ、それぞれガジュマル、デイゴ、アコウを表現しているという。それらの木の根元の中心には市章が印され、木々の間にはエイ、マンタ、及びイソギンチャクとクマノミの共生が描かれている。これらのデザインを取り囲むように枝状サンゴが描かれている。このデザインマンホールは白保の陸と海の生物の豊かさを表現すると同時に、

白保区 たくさんの動植物がいる

竹富町 Taketomi Town

Data

- 町木：イヌマキ（キャーギ）
- 町花：ゲットウ（サミン）
- 町鳥：アカショウビン（ゴッカーロ）
- 町蝶：ツマベニチョウ
- 町魚：カスミアジ（ガーラ）
- 町貝：スイジガイ

（昭和53年6月13日制定）

竹富町について

八重山村の一村では自治統治上不便との理由から、大正三年四月一日県令で八重山村は石垣、大浜、竹富、与那国の四ヶ村に分村する。

竹富村は竹富、黒島、新城、小浜、鳩間、西表、波照間の七ヶ字が行政区となる。昭和二十三年に南部琉球軍政府の認可を得て町に昇格し、現在に至る。

竹富町は日本最南端の町である。「海と空の真ん中に、笑顔にあふれるくらしがある。日本最南端の大自然と文化のまち」をキャッチフレーズにしている。竹富島は、赤瓦屋根の木造家屋、琉球石灰岩の石積み、白砂の道に代表される伝統的な町並みが残されていることで、昭和六十二年に文化庁から「伝統的建造物群保存地区」に指定されている。また景観上の配慮から電線類の

町章のこぼれ話

竹富町の「竹」の字を図案化したもので、竹のごとく根強く栄え、その円は離島を結ぶ町民の「和」と限りない竹富町の躍進を表している。昭和四十五年一月二十日制定された。

竹富町 満点の星を表現

地中化が進められている。
竹富島のマンホールの蓋は真っ白な無地そのもので、その中央に町章が印されている。この島の道は昔ながらの白砂の道で、マンホールの蓋も白砂にマッチするように工夫されている。竹富島の景観上から白色無地にしたと思われる。

南の果てに輝く星

波照間島は日本の有人島で最南端に位置し、デザインマンホールの蓋には高那崎にある星空観測タワー、南十字星が輝く星空と海が描かれている。星空観測タワーは国のコミュニティーアイ

高那崎の星空観測タワー

ランド事業を導入して、多目的交流広場とともに整備されて、平成六年に開館し、天体観測を楽しみに訪れる人が多いという。

「はてるま」は「果てのうるま(サンゴ)」という意味に由来するという。波照間島のことを石垣島ではパティローマ、パティローと呼び、地元の人はパチラーと呼ぶという。この呼称について語源論争がかつて行われたが、結論は出てないようである。

Column 7

マンホール博覧会
パビリオン❹ー「足元に何かいる」

キジムナー（大宜味村）

大東太鼓（南大東村）

ターム君（金武町）

獅子（宜野座村）

農業用水のマンホール（志喜屋区）

エイサー（うるま市）

与那国町 Yonaguni Town

Data

町　木：クバ　　　　町　花：テッポウユリ
町花木：サルスベリ　町　蝶：ヨナグニサン
町　鳥：メジロ　　　町　魚：カジキ
（昭和62年4月15日制定）

与那国町について

与那国島は寛永五（一六二八）年八重山が大浜、石垣、宮良の三間切に区画された時、大浜間切の所属となる。明和五（一七六八）年間切区画が変更された時、与那国島は遠隔地のため間切外とする。明治四十一年、島嶼町村制により、与那国島と八重山の三間切をもって八重山村となり、大正三年には四村分立によって与那国村が誕生した。昭和二十二年町制施行で与那国町へ昇格した。

「日本最西端の島　与那国町　健やかな自然・人・生活を育む島ドゥナン」をキャッチフレーズにしている。また与那国馬、ヨナグニサン、カジキ漁がよく知られている。

与那国町 躍動感があるカジキが印象的

世界最大の蝶をデザイン

町のデザインマンホールの一つには与那国馬、町蝶のヨナグニサン、西崎灯台、町魚のカジキ、西崎灯台が、さらに中央には町章を太陽に見立てて西端の海に沈む入日の美しさが描かれている。同デザインで「ひがわ　おすい」と書かれたものもある。

もう一つの蓋は中央に町章が印され、その周りに波頭の連続模様が同心円状に描かれている。与那国島が海に囲まれていることを表現しているのであろう。

与那国馬は日本に現存する八種の在来馬の一つで、日本最小の馬である。ヨナグニサンは世界最大の蛾で、地元では「アヤミハビル（模様のある蝶）」と呼ばれている。その生態などを学ぶことができる「アヤミハベル館」がある。昭和六十

町章のこぼれ話

与那国の文字をひとまとめにして、当町の明るく伸びゆく姿を表徴している。昭和四十年十二月二十八日制定される。

与那国町 前ページと同じデザインで文字の異なるバージョンも

年に県の天然記念物に指定されており、さらにレッドデータおきなわで絶滅危惧Ⅱ類（VU）に指定されている。

宇良部岳と久部良岳は島の高峰で、ともにヨナグニサンの重要な生息地であり、昭和六十年三月二十九日県の天然記念物に指定されている。島では国際カジキ釣り大会が毎年七月の第一日曜日をはさんで三日間開催され、勝負はトローリング、沖釣り、磯釣りの三部門で競われるという。

130

Column 8

マンホール博覧会
パビリオン❺-「動物」

ケラマジカ(座間味村)

ウマ(宮古島市)

赤馬(石垣市)

ヨナグニウマ(与那国町)

闘牛(うるま市)

闘牛(うるま市)

南大東村 Minami Daito Village

Data

村　木：ダイトウビロウ
村　花：ハイビスカス
（昭和61年6月12日制定）

南大東村について

大東島の島の名前は「ウフアガリジマ」に由来するという。また、ボロジノ島という名前で十九世紀前半に海図や地図に現れた。ボロジノは島を発見したロシア海軍の艦船「ボロジノ号」の船名にちなむという。南大東島は明治三十三年一月二十三日に八丈島から荒波を乗り越えてきた二十三人が上陸し開拓してきた島で、大地に刻み込まれた開拓者魂は今も人々の心の中に脈々と受け継がれているという。昭和二十一年六月十二日に村制が施行され、南大東村となる。「人と自然が活きるフロンティアアイランド」をキャッチフレーズにしている。

村章のこぼれ話

南大東村の「ミナミ大」を円形図案化し、上の六本の線はミナミの「ミ・ミ」で村内六字を、下の半円は「ナ」で村の飛躍を、中央は「大」で村民の団結を表現したものである。昭和五十一年十二月二十七日制定された。

南大東村　開拓民がもたらした大東太鼓

勇壮な大東太鼓とビロウの木

デザインマンホールには、大東太鼓を叩いている絵を中心にして村章、村花のハイビスカス、村木のダイトウビロウや波頭が描かれている。

国指定天然記念物として、ダイトウオオコウモリが昭和四十八年六月二日に、南大東島東海岸植物群落と大池のオヒルギ群落が、昭和五十年三月十八日に、それぞれ指定される。

大東太鼓は南大東島を開拓した人々の故郷である八丈島から伝わった和太鼓という。

デザインマンホール以外に模様の異なる蓋が四つほどある。大正時代に植えられたというリュウキュウマツの大木が島の風情を豊かにしている。

マンホール探しの
著者近影
（小鍋玉子さん撮影）

おわりに

A Picture Book of Okinawan
Manhole Cover Design

路上でデザインマンホール蓋を見ているうちに、散策しながらそれらを撮影して集めてみるのも面白いのではないかと思い立った。素人ながらも写真同好会の一員として、そのように撮りだめてきた結果が本書となった。

　マンホールの蓋を眺めていると、隔世の感がある。下水道のことを考えると、沖縄のトイレはウワーフール（豚の便所）、戦後の穴掘り便所、ドラム缶便所、汲み取り便所、水洗便所と、実に時代に適応して進化してきた。下水道マンホール蓋のデザインも同じように進化してきて、各自治体独自の特色がうまく表現されるようになっている。土地ごとのシンボル・文化・歴史などが盛り込まれ、眺めて見ているだけでもどのような特色があ

るかを教えてくれる。
　つまりマンホール蓋は「路上の先生」なのだ。日常的にマンホール蓋を見ていても、そのデザイン性や地域性はあまり知覚されていないのが現状だ。誰かに、たとえ家の近所にある蓋の写真を見せても「こんなものが描かれていたとは知らなかった」というありさま。これでは「路上の蓋先生」には失礼であろうと思った次第である。芸術性・安全性豊かな蓋先生に感謝しつつ、本書が下水道の接続率向上にいささかでも寄与することを願っている。
　発刊にご協力いただき、読みやすい丁寧なる編集をしてくださったボーダーインクの喜納えりかさんに大変お世話になりました。ありがとうございました。

おもな参考文献・ウェブサイトなど（順不同）

【文献等】

『水と緑と朝陽の里　知念』［村勢要覧　平成八年度］

『南城市の下水道〜海と緑と光あふれる南城市〜　事業概要』平成二十年四月

『沖縄の聖地』湧上元雄・大城秀子著　むぎ社　一九九七年

『古琉球』伊波普猷　琉球新報社　昭和十七年

『伊波普猷全集　第七巻　古琉球の歌謡に就きて』平凡社　一九七五年

『琉球古語辞典混効験集の研究』南島文化叢書十七　池宮正治　第一書房　一九九五年

『琉球共産村落の研究』田村浩　至言社　一九六九年

『佐敷町史　二　民俗』佐敷町史編集委員会　一九八四年

『玉城村誌』玉城村／編　昭和五十二年

『玉城村の文化財』玉城村教育委員会　平成十五年

『グスクとカー（湧水・泉）水の郷』玉城村役場企画財政室編　一九九七年

『なんじょう文化　第六号』南城市文化協会連合会

『沖縄文化史辞典』真栄田義見、三隅治雄、源武雄編　東京堂出版　一九七二年

『角川　日本地名大辞典　47　沖縄県』角川書店　一九八六年

『図典日本の市町村章』小学館辞典編集部　小学館　二〇〇六年

『沖縄の文化財』沖縄県教育委員会　一九八七年

『日本のマンホール　写真集』監修・建設省下水道部　水道産業新聞社　一九九七年

『琉球国由来記』　琉球王府編　風土記社　一九八八年
『伊波普猷全集　第四巻』「沖縄考」平凡社　一九七四年
『沖縄「地理・地名・地図」の謎』実業之日本社　二〇一四年
『南島風土記』東恩納寛惇著　沖縄郷土文化研究会　一九七二年
『おもろさうし　日本思想大系　十八』岩波書店
『沖縄大百科事典』上・中・下巻　沖縄タイムス社　一九八三年
池宮正治「神女と白馬と馬の口取り」『首里城研究№7』首里城研究会編　二〇〇三年
『改訂・沖縄県の絶滅のおそれのある野生　生物　動物編　レッドデータおきなわ　沖縄県』二〇〇五年
糸満　海人工房・資料館「糸満漁業史年表」
ぶながやの里宣言建立碑
座間味村ガイドマップ
島まるごとミュージアム　南大東島まるごと宝マップ

【新聞記事】
「県内三ヵ所名勝に　天然記念物も一件　文化審議会が答申」琉球新報　平成二十七年六月二十日
「国名勝県内から2件　天然記念物も1件　近く正式指定」沖縄タイムス　平成二十七年六月二十日
「タコライスの老舗『千里』惜しまれ幕　創業31年　自慢の味、系列店に」琉球新報　平成二十七年七月十六日
「サワフジの詩歌碑お披露目」沖縄タイムス　平成二十七年七月二十五日
「平和の歌後世に　西原　サワフジの詩歌碑建立」琉球新報　平成二十七年七月二十八日
「伊波メンサー織・伊波貞子さん地域賞　伝統文化ポーラ賞」琉球新報　二〇〇九年八月十一日

【ウェブサイト】

沖縄県ホームページ

各市町村ホームページ
南城市・与那原町・具志頭村・八重瀬町・南風原町・糸満市・豊見城市・那覇市・南風原町・西原町・浦添市・宜野湾市・中城村・北中城村・北谷町・恩納村・金武町・宜野座村・名護市・本部町・伊平屋村・伊是名村・渡嘉敷村・座間味村・渡名喜村・粟国村・宮古島市・石垣市・竹富町・南大東島・東村・大宜味村（旧町村含む）

農林水産省

wikipedia

国土交通省　http://www.mlit.go.jp/crd/sewerage/kouka/manhole/kyushu-okinawa.html

沖縄文化工芸研究所　http://www.shuri-ori.com/syuriori.html

沖縄県工芸振興センター　http://c8.x316v.smilestart.ne.jp/kougei/syuri.html

下水道と歌三線と横笛と　http://rimbow.ti-da.net/c163393.html

南風原観光ガイド　http://www.haebaru-kankou.jp/texitile/ryukyu-kasuri.html

琉球絣事業協同組合　http://ryukyukasuri.com/?page-id=8

　http://ryukyukasuri.com/?page-id=11

中城村の文化財　http://www.nakagusuku.or.jp/chiiki/bunka/toyomu.html

KOZA WEB　http://kozaweb.jp/eisa/sengen.html

　http://kozaweb.jp/eisa/character.html

琉球村日記　http://www.ryukyumura.co.jp/blog/2009/10/post_232.html

沖縄・伝統文化	http://blog.goo.ne.jp/l-needyou
全国観るなび	http://www.nihon-kankou.or.jp/
ディーズパルス沖縄	http://www.d-spulse.com/whale/kujira1.html
島の風	http://www.shimanokaze.jp/contents/info.html
沖縄の風景	http://okinawanofukei.ti-da.net/c103001.html
一般社団法人　いぜな島観光協会	http://www.izena-kanko.jp/
「沖縄」を読む	http://blog.goo.ne.jp/atmyoo/e/895122c21cd81979b91188262a75e5
日本の郷文化	http://jpsatobuka.net/meisan/okinawa/okinawa-18.html
沖縄発！役に立たない写真集	http://okinawa.s41.xrea.com/tonakinadeshiko.htm
おきなわ　緑と花のひろば	http://www.midorihana-okinawa.jp/?page-id=90
	http://www.midorihana-okinawa.jp/?page_id=90
環境省	http://www.env.go.jp/press/press.php?serial=10338
本場　久米島紬	http://www.kume-tumugi.com/
	www.env.go.jp/press/files/jp/21555.pdf
八重山毎日新聞「波照間島の星空観測タワー」	http://www.y-mainichi.co.jp/news/5532/
「電線地中化スタート　竹富島町道大舛線」	http://www.y-mainichi.co.jp/news/12708/
石垣島を楽しむ観光ナビ	http://ishigakijima-navi.net/manhol/
与那国町漁協	http://yonaguni-gyokyou.org/outline/index.html
歩鉄の達人	http:www.hotetu.net/manhole/okinawaken.html
日本☆地域番付	http://area-info.jpn.org/EXPRESS470007.html
ネオアイランド	http://blogs.yahoo.co.jp/neoisland2/26511672.html
ryuQ「シーヤーマー」	http://ryuqspecial.ti-da.net/e2372400.html

＊その他、多くのウェブサイトを参考にさせていただきました。

著者略歴

仲宗根　幸男（なかそね・ゆきお）
南城市知念生まれ。

1969年　　　九州大学大学院農学研究科博士課程中退
1970年11月　農学博士（九州大学）
2005年　　　琉球大学を定年退官

著書：『沖縄の貝・カニ・エビ』（共著）『沖縄の生物』（共著）『沖縄の自然百科19　オカヤドカリ』『週刊朝日百科　動物たちの地球68』（共著）『世界に拓く沖縄研究』（共著）『琉球列島の陸生生物』（共著）。

沖縄のデザインマンホール図鑑

2016年4月15日　初版第一刷発行
著　者／仲宗根幸男
発行者／宮城正勝
発行所／(有)ボーダーインク
　　　　〒902-0076　沖縄県那覇市与儀226-3
　　　　tel.098(835)2777、fax.098(835)2840
印刷所／(株)東洋企画印刷
ISBN978-4-89982-298-1
©Yukio Nakasone,2016